If You Remember,
I'll Remember

THE BLOCK MUSEUM OF ART, NORTHWESTERN UNIVERSITY

IF YOU REMEMBER, I'LL REMEMBER

Edited by Janet Dees and Susy Bielak

CONTENTS

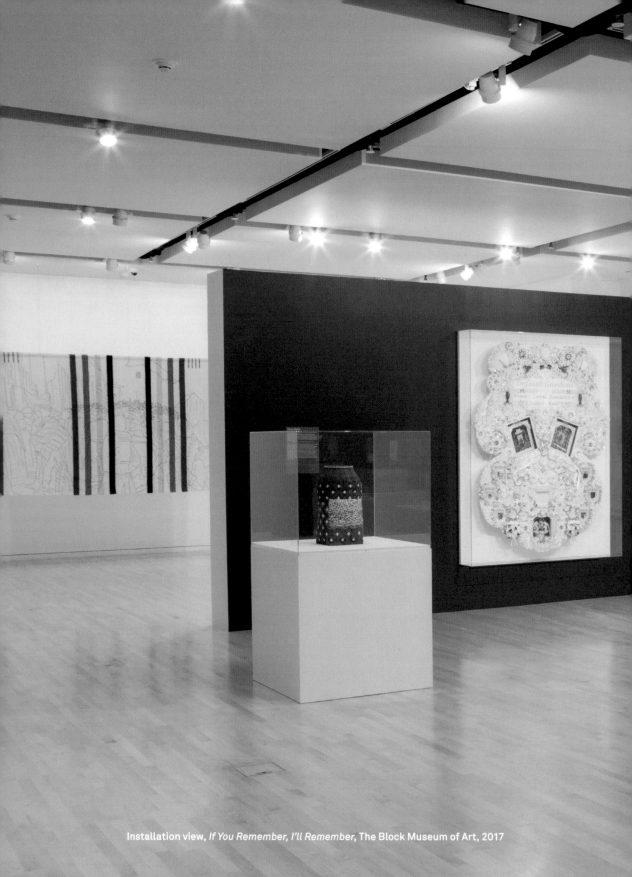

Installation view, *If You Remember, I'll Remember*, The Block Museum of Art, 2017

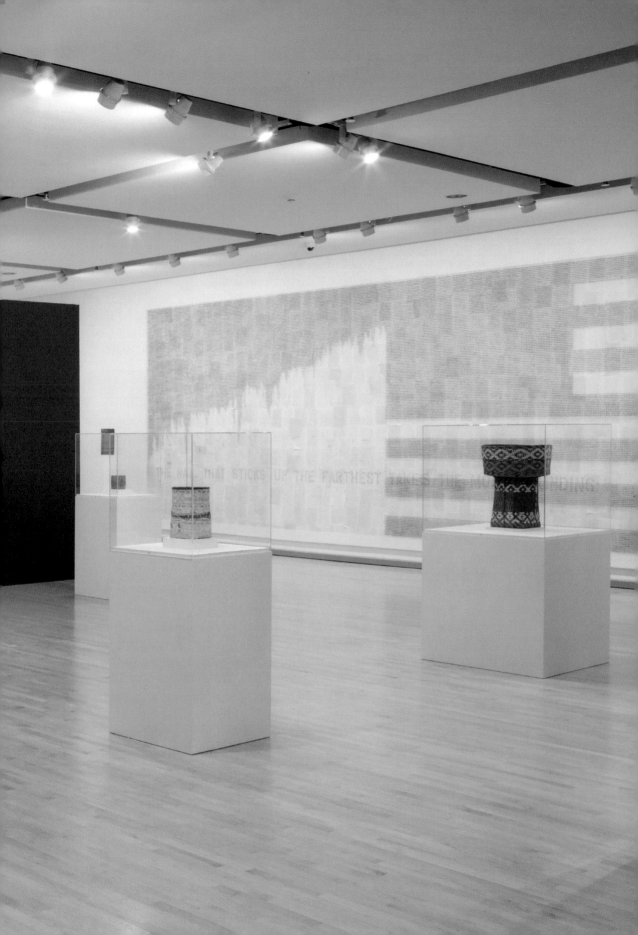

FOREWORD

Lisa G. Corrin, Ellen Philips Katz Director

This publication has been conceived as an opportunity for The Block Museum of Art to share with our field what we have learned from our experiences, and those of our partners, in realizing *If You Remember, I'll Remember*. Our holistic approach to this project, in which exhibition and engagement were inextricable, marked a turning point—a strengthening of The Block's commitment to collaborative processes as equal to a project outcome and to a belief that what leads up to an exhibition can expand the museum's reach and expand its impact. At The Block, art serves as a springboard for conversations about current ideas and issues, and for grappling with what it means to be human and to connect to the humanity of others. Working closely with a range of campus and community partners throughout the development and during the presentation of *If You Remember, I'll Remember* built shared investment in and connection with the works of art on a level we had never previously achieved. *If You Remember, I'll Remember* was an invitation for artists and visitors to join The Block in more fully realizing this mission. This book is an invitation to our peers to join this conversation.

Contemporary art can be challenging for many museum visitors. We believe it is the museum's responsibility to remove barriers to participation by creating a generous and inclusive environment, an environment that values what each visitor brings to their experience of looking. *If You Remember, I'll Remember* centered the voices of our visitors along with those of artists in a spirit of open, mutual exchange. Thus, the artists' archival research and poetic evocations of the past came alive and were enlivened through the personal stories and reflections of museumgoers. The Block's exhibition space was filled with their voices. At times, it could be joyfully boisterous with shared laughter and, other times, subdued when acknowledging loss. In an "equity sewing circle," Northwestern students and Evanston residents stitched quilt panels with artist Marie Watt, suturing together their aspirations for the diverse city they share. In another gathering, Japanese American elders recalled World War II internment camps where their youth was forged behind barbed wire. Their truth-telling was followed by participants inserting rusted nails to Kristine Aono's

participatory artwork, each nail a memorial for those imprisoned, including the family of the artist.

The structure of this book embodies our commitment to reflecting on these partnerships and gatherings. Their reflections have much to teach us and listening to their experiences has been transformative to The Block's approach to future projects. While the final realization of the project occurred in 2017, the methodology we bring to our present work is imprinted with what we learned. We now remember and honor this experience through the questions we ask about what we do and by activating what art can do in our museum.

I wish to acknowledge the leadership of Janet Dees, The Block's Steven and Lisa Munster Tananbaum Curator of Modern and Contemporary Art, who conceived of *If You Remember, I'll Remember* in 2015 based on her original research and brought an inspired curatorial approach to its realization. Janet worked in tandem with her colleagues, Susy Bielak, former Associate Director of Engagement/ Curator of Public Practice, and Lauren Watkins, former Engagement Manager, both of whom brought extensive experience in collaborative programming to fulfill the project's potential. We are extremely grateful to the seven artists whose work is featured: Kristine Aono, Shan Goshorn, Samantha Hill, Bradley McCallum and Jacqueline Tarry, Dario Robleto, and Marie Watt. Our community partnerships were essential to the project, and we thank our partners for their participation and their contributions to this publication. As always, the dedicated Block team embraced the project, adapting their own processes to ensure its success. Finally, we thank Northwestern University, especially the Office of the Provost, for always supporting and championing the work of its academic art museum. Northwestern's encouragement of collaboration across the university has made The Block a distinctive site for interdisciplinary teaching, learning, and research and a site in which nourishing empathy through projects like *If You Remember I'll Remember* in turn nourishes Northwestern.

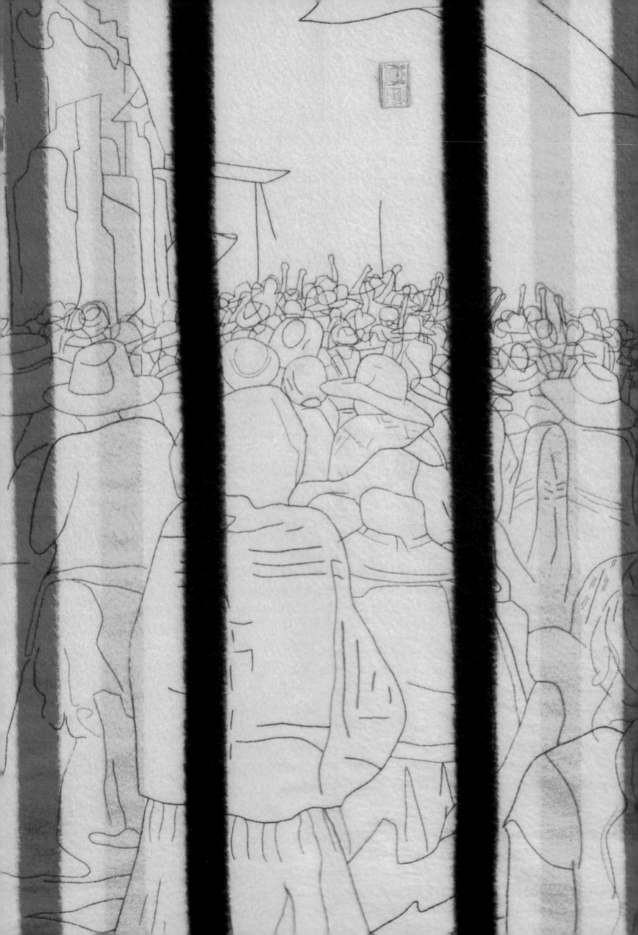

ACKNOWLEDGMENTS

Susy Bielak and Janet Dees

The breadth of our acknowledgments reflects the truly collaborative nature of *If You Remember*. We could not have manifested the exhibition without the support of so many, nor could we have realized the constellation of artist projects, in-depth programs, and activities that also constituted this project.

First, we would like to thank artists Kristine Aono, Shan Goshorn, Samantha Hill, Bradley McCallum, Dario Robleto, Jacqueline Tarry, and Marie Watt for their artistic vision and depth of thought, generosity and collegiality, and commitment and inspiration. Our work would not have been possible without theirs. We particularly thank Kristine Aono and Marie Watt for their extra investment in collaborating on engagement programs and creating new work.

The exhibition was funded through support from the Bernstein Family Contemporary Art Fund; Stephen, Dianne, Katy, and Becky Loeb; the Diane and Craig Solomon Contemporary Art Fund; the Illinois Arts Council Agency; and the Mary and Leigh Block Endowment. We are extremely grateful to these funders, who helped to make this exhibition possible.

We would like to express our deep thanks to the Sandra L. Riggs Publications Fund, which has enabled The Block to expand and redefine its publishing program, extend the lives of our exhibitions through books, and share our research with broader audiences. This is one in a series of publications made possible by the generous funding of Sandra L. Riggs. In addition, we would like to acknowledge Riggs and members of the Block Leadership Circle whose gifts supported the purchase of Shan Goshorn's *Cherokee Burden Basket: A Song for Balance* for The Block's collection.

We would like to thank the institutional and private lenders to the exhibition: The Gilcrease Museum of Art, Tulsa, OK; The Mint Museum, Charlotte, NC; Julie Blakeslee; Uschi and William Butler; Pamela Rosenthal and Samuel Wertheimer; Margo and Frank J. Walter III; and Susan and Bruce Winthrop.

Additional thanks is extended to Jane Beebe and Caitlin Moore of PDX Contemporary Art, Portland, OR; Greg Kucera Gallery, Seattle;

Marie Watt, *Witness* (detail), 2015.

Lori Cassady and Kerry Inman of Inman Gallery, Houston; Madalyn Barelle, formerly of Marie Watt Studio; and J. Lorae Davis and Rose McCracken of Shan Goshorn's studio for connecting us with lenders, supporting the artists, and assisting with various logistics. We acknowledge Ryan A. Rice and Sonya Kelliher-Combs for facilitating connections to the artists Shan Goshorn and Samantha Hill.

We thank the contributors to this publication: Melissa Blount, Joshua Chambers-Letson, Lisa Doi, Ninah Divine, Anna Takada, and Lauren Watkins. We are greatly appreciative of the feedback given at different stages of the manuscript development by Elise Archias, Kathleen Bickford Berzock, Fred Schmalz, Joshua Chambers-Letson, Lisa Corrin, and Michael Christiano and early editing by Melanie Garcia Sympson and Holly Warren. Special thanks are due to Corinne Granof for stepping up to help shepherd this publication to completion. We are also grateful to editor/project manager Joanna Ahlberg and designer Peter Ahlberg of AHL&CO for producing a beautiful book.

As we share in the essays in this volume, *If You Remember, I'll Remember* was a project that included an exhibition as a midpoint in a larger process of building relationships and experiences with dozens of people through ongoing collaborations and conversations. There were hundreds of people whose perspectives and hands contributed to the project. Here, we wish to acknowledge people who were especially dedicated partners in the work and others whose voices helped shape what transpired.

Many facets of this project were made possible out of deep, ongoing collaborations with a few key individuals. Our sincere gratitude goes to Ninah Divine, then of Northwestern's Native American and Indigenous Peoples Steering Group out of the Office of the President, who served as an ongoing collaborator and driving force of the Equity Sewing Circle, one of our largest and most complex public programs. We thank Jasmine Gurneau and Christine Munteanu, both working at the time in Northwestern's office of Multicultural Student Affairs, who also lent their time and energy to program development and fostering connections on and off campus. We would like to thank Anna Takada, then of Northwestern's Multicultural Student Affairs, who worked with us week after week to realize numerous projects, public programs, behind-the-scenes activities, and connections to students and community groups in Chicago. We also offer our thanks to Northwestern professor Kelly Wisecup, who was with us every step of the way as a host to visiting artists, volunteer facilitator, program panelist, and ongoing ally for the project.

We wish to thank other members of Northwestern faculty who served as thought partners at various stages in the process: Michael Allen, Laura Brueck, Joshua Chambers-Letson, Laura Hein, Laura Fugikawa, Shalini Shankar, Elizabeth Son, and Ji-Yeon Yuh. They

offered advice and contacts in the early phases of outreach and program development, and some of them also offered their scholarly perspectives and expertise as panelists.

We wish to thank the following Northwestern student leaders who partnered with us around Kristine Aono's and Marie Watt's activities, including two of our most complex public programs: Bonnie Etherington, Lorenzo Gudino, Alexander Harusuke Furuya, and Stacy Jacki Tsai. We also wish to recognize other student collaborators who took part in fall site visits with these artists and subsequently organized their own student-led dialogues and programs using the exhibition as a touchstone: Daniela Guerrero, Jess Lewis, Patricia Nguyen, and LaCharles Ward.

Individuals, as well as entire units and programs from across the university, also contributed to the project as ambassadors, allies, and supporters; we thank them for their ongoing partnership. Heidi Gross from the Center for Civic Engagement offered terrific leads on relationships we might forge. Faculty and staff from the Alice Kaplan Institute for the Humanities contributed to early planning conversations and co-sponsored ensuing programs: Tom Burke, Jill Mannor, Rosie Roche, and Wendy Wall. Charles Kellom, then of Multicultural Student Affairs, advised us early on and supported members of his team in becoming primary collaborators. Members of the Native American and Indigenous Peoples Steering Group, comprised of faculty, staff, and students and led by Professor Emeritus Loren Gighlione, offered ongoing support. Jabbar Bennett and Theresa Bratanch, formerly of the Office of Diversity and Inclusion, similarly served as allies who helped to share our work broadly across campus. Rob Brown and Noor Ali from Social Justice Education supported the project early on and later led a training to equip The Block's student docents with skills to facilitate dialogue in the exhibition with care and sensitivity.

We are grateful to partners who helped us forge connections to our local communities beyond campus. Alan Anderson, formerly of Northwestern's Office of Neighborhood and Community Relations, was a key sounding board, advisor, and supporter of the project in forging connections with Evanston residents. In addition, Kristen Perkins of Northwestern and Evanston Township High School was also an ambassador for the project, helping promote the exhibition and programs as resources to our local high school teachers and students. We also wish to thank Maggie Queeney of the Poetry Foundation, who designed and facilitated a creative writing workshop inspired by the exhibition. We are grateful to Casey Varela and Keisha Bernard at Youth & Opportunity United (Y.O.U.), who worked with us over months to develop a series of touch points that engaged dozens of Y.O.U. staff, youth, and families.

We are grateful also to members of community organizations who lent their time and perspective to the project. Many planning meeting participants and program contributors have already been named in these acknowledgments. Here we would like to additionally acknowledge Hope Williams of the American Indian Health Service of Chicago, who volunteered her time in facilitating sewing circles.

Although all of our programs and activities were developed out of partnerships, one of our public programs, Deru Kugi Wa Utareru: Stories of Internment and Remembrance, would not have been possible without the partnership of numerous individuals and organizations. Our gratitude goes to Jane Hidaka, Yuki Hiyama, Enoch Kanaya, Jean Mishima, James Mita, and Merry Oya, who generously shared their stories with us. We thank Anna Takada, who was the driving force behind a program at The Block highlighting their lived experiences. We wish to thank Mike Takada, Justine Urbikas, and Ryan Yokota, of the Japanese American Service Committee; Mari Yamagiwa of the Japanese American Citizens League; and Jean Mishima of the Chicago Japanese American Historical Society, who integrated this program into the citywide Day of Remembrance. We also thank the individuals who volunteered to help moderate conversations, including members of the Japanese American Citizens League Next Generation Nikkei: Lisa Doi, Jeannie Harrell, Greg Kimura, Jessica Wang, Anne Watanabe, and Jon Yamaguchi; and Northwestern students: Alexander Harusuke Furuya, Stacy Jacki Tsai, Joyce Wang, and Eric Zheng.

Our work was also heavily informed by countless other conversations we had starting in spring 2016 and continuing up to and through the run of the exhibition in 2017 with people on campus and off-campus, many of whom have already been named. These conversations, as we describe more fully in the essay "Imprint of Exchange," allowed us to explore what kinds of exchanges and experiences would be most meaningful at Northwestern and in Evanston and Chicago. Extended lists of participants and partners in the full arc of the project appear as an appendix (see page 121).

Many Block staff members and affiliates have contributed to the project. We recognize and are grateful for the excellent work of the crew members: Samantha Belden, Araidia Blackburn, Dave Ford, Laurel Hauge, Carl Kauffman, Steve Lalik, Esau McGhee, Christian Neill, Dillon Roberts, Alex Schutz. Additionally we would like to thank Joan Giroux and her students from Columbia College: Katherine Anderson, Caitlyn Brunner, Charles Long, Cassandra Meek, Emily Moe, Tyke Riggs, and Jeremy Weber for their assistance with Kristine Aono's installation. On the museum staff, we wish to thank Kathleen Bickford Berzock and Lisa Corrin, who supported the project from the beginning. We thank Dan Silverstein and Mark Leonhart for leadership of the exhibition installation and their openness to

exploring new ways of working, as well as Kristina Bottomley. Lindsay Bosch and Caroline Claflin deserve special mention for their public relations work in spreading the word about and telling the story of *If You Remember*, as does Holly Warren for logistical support for the numerous engagement activities and events. We would like to acknowledge former staff members Justin Lintelman and Michelle Puetz for co-curating the *If You Remember* film series. We also thank the other members of The Block team for helping to make this project and publication possible: Aaron Chatman, Rocio Castillo, Rebecca Lyon, Michael Metzger, Jenna Robertson, Essi Rönkkö, Joseph Scott, Rita Shorts, Jeff Smith, James Stauber, Vincent Taylor, and former staff members Tess Coffey, Brycen Doby, Mollie Edgar, James Foster, Helen Hilken, Carl Kauffman, Alexandra Kotoch, Veronica Robinson, Samantha Topol, and Elizabeth Wolf.

We also wish to thank The Block's student workers and docents, especially Rachel D'Amato, Riona Ryan, and Ava Szychalski, for their work behind-the-scenes throughout this project. Student docents who pitched in at public programs and led dozens of tours of the exhibition were Kelsey Allen-Niesen, Yiran Chi, Florence Fu, Vanessa Gao, Rachel Gradone, Marisa Guo, Matthew Guzman, Cammy Harris, Paul Kim, Nina Matti, Allison Miller, Emma Montgomery, Montgomery Nelson, Julia Poppy, Cindy Qian, James Tsui, Yiran Wang, Jiaming Wu, and Moling Zhang.

In addition, the installation of the exhibition posed unique challenges that required the support of staff from other parts of the university. We would like to express our appreciation to Gwen Butler, Leland E. Roth, and Peter Sackett of Risk Management; Aaron Laudersmith of the Wirtz Theater Scene Shop; Josh Ippel, Matt Martin, and Brendan Meara from the Department of Art Theory & Practice; and Stacia Campbell of *The Daily Northwestern*.

As indicated above, *If You Remember* was a project built from a web of contributions and connections. Given the participatory nature of many of these projects, it is impossible to name everyone who lent their hands and perspective to *If You Remember*. That said, we conclude with special thanks to each and every one of the individuals who contributed to this project. Over the course of developing, implementing, and reflecting upon *If You Remember*, you have broadened our perspectives. Your support and participation, care and criticality were elemental in manifesting this project. You remind us of what is made possible by art and of the need to continue and deepen this work.

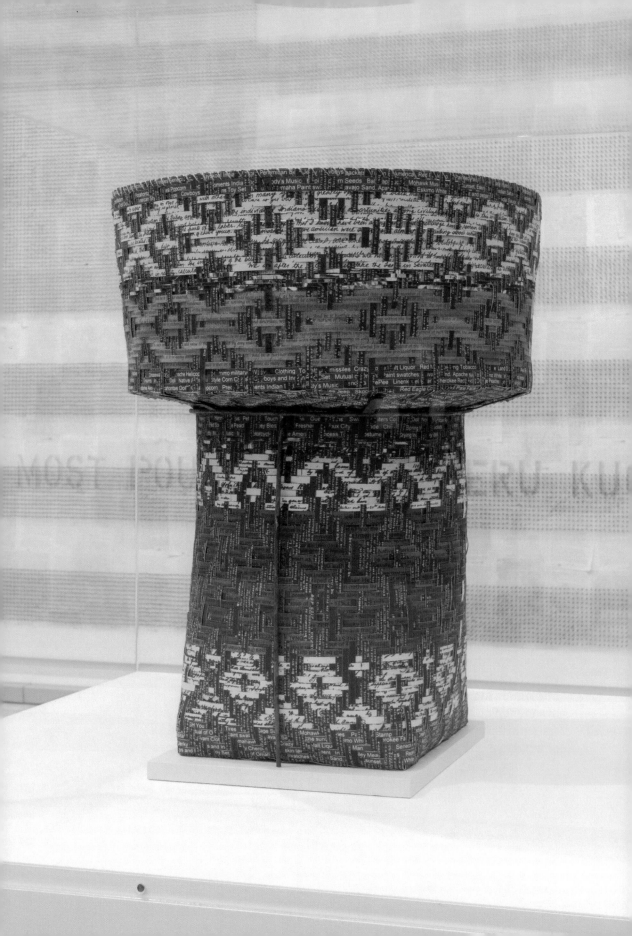

INTRODUCTION

Susy Bielak and Janet Dees

In the face of magnitudes of pain in the world that come to us in pictures immediate and raw, many of us care too much and see no evident place for our care to go. But compassion goes about finding the work that can be done.[1]—Krista Tippett

Poetry is not a luxury. It is a vital necessity of our existence. It forms the quality of light within which we predicate our hopes and dreams toward survival and change, first made into language, then into idea, then into more tangible action. Poetry is the way we help give name to the nameless so it can be thought. The farthest horizons of our hopes and fears are cobbled by our poems, carved from the rock experiences of our daily lives.[2]—Audre Lorde

If You Remember, I'll Remember, a project developed at The Block Museum of Art in 2016–17, offered an invitation to reflect upon the connection between the past and present through works of art, collaborations, dialogues, and experiences in and outside of the gallery. Exploring themes of love, mourning, war, relocation, and resistance in nineteenth- and twentieth-century America, the exhibition *If You Remember, I'll Remember* brought together the work of seven contemporary artists whose practices are based in archival research and integrate historic documents and objects: Kristine Aono (b. 1960), Shan Goshorn (b. 1957), Samantha Hill (b. 1974), McCallum & Tarry (active 1998–2013), Dario Robleto (b. 1972), and Marie Watt (b. 1967).

If You Remember recognized and honored the specificities of the histories with which each artist and artwork engaged, such as the internment of Japanese Americans during World War II, Native American sovereignty, and African American struggles for civil rights, while seeking, through their juxtaposition, to spark questions and provoke insights into the ways these histories may be intertwined. Recognizing that the exhibition presented an opportunity to contemplate an integrated view of the American past and consider

Installation view of *If You Remember, I'll Remember*, The Block Museum of Art, 2017, with artwork by Shan Goshorn and Kristine Aono.

histories that resonate with pressing contemporary social concerns, The Block used it as a jumping-off point to develop a holistic project.

If You Remember was a cross-departmental undertaking, where boundaries between curatorial and engagement departments were porous. It situated an exhibition as a significant touchstone at the midpoint in a larger arc of experience; engagement programs and interlocking artist projects were developed to function as integral extensions of the exhibition, rather than activities ancillary to it. All of this was built from a network of collaborations.

The exhibition was conceived at the end of 2015 as the product of a long-standing interest on the part of curator Janet Dees in the work of artists who critically engage history, intersecting a cultural landscape marked by mass shootings and mass protests. Among the contemporaneous events that formed the backdrop of the exhibition's development were the June 2015 mass shooting at the Emanuel African Methodist Episcopal Church in Charleston, South Carolina, where nine parishioners were killed by white supremacist Dylann Roof, and the November 2015 protests in Chicago over the release of video footage of the police killing of 17-year-old African American Laquan McDonald, which followed in the vein of Black Lives Matter protests that had been ongoing since 2013. The exhibition planning and presentation also overlapped with the highly divisive 2016 US presidential election and subsequent unrest.

The heightened socio-political tensions amplified the contemporary relevance of the themes and histories engaged in the exhibition and the urgency of creating spaces in which people could come together to reflect, share, learn, mourn, discuss, and find common ground. Immediately after the exhibition's participating artists were selected by Dees, the process of developing *If You Remember* continued with a partnership between us and our subsequent invitation to exhibiting artists Kristine Aono and Marie Watt to develop entwined engagement programs and artists' projects in collaboration with The Block and members of our communities. Aono and Watt were chosen based on the participatory and collaborative nature of their respective artistic practices, their willingness to partake in an open process, and their availability to devote the time necessary for this process to unfold. Susy Bielak and Engagement Manager Lauren Watkins then extended invitations to colleagues and students on Northwestern University's campus, along with community organizations and stakeholders, to be thought partners, collaborators, co-conspirators, and critics. Significant serial engagement projects were developed with Aono and Watt and in conversation with their work. Finally, exhibition visitors and program attendees were invited to be active participants in projects, whether by contributing to a large-scale installation or adding their voices to the ongoing dialogue.

This approach—working through partnership across departments within the museum, across campus, and with local communities—builds upon work that has been ongoing at The Block since 2013 (further discussed in the essay "Imprint of Exchange" in this volume). This publication serves as a record of the entire project, developed through discussion and collaboration with artists, community partners, and a range of stakeholders from Northwestern University, of which The Block Museum of Art is a part. The retrospective nature of the publication allows for consideration of the project's production and reception, the inclusion of participants' voices, and reflection upon the process of museums working closely with multiple stakeholders. Often, the voices of participants are not included in the record of a project. Here, we have designed this text to integrate these voices, acknowledging that *If You Remember* was a shared project. This approach aims to contribute a valuable case study to current methodological conversations about collaborations between artists, museums, and communities.

This books begins with the essay "If You Remember, I'll Remember," which lays out the conceptual, historical, and material concerns taken up by the works in the exhibition and reflects upon the socio-political context of the exhibition, including the Black Lives Matter movement, the Dakota Access Pipeline protests, and the mainstreaming of xenophobic rhetoric in public discourse.

The essay "Imprint of Exchange: Engagement and Public Practice in *If You Remember*" by Susy Bielak and Lauren Watkins situates the project within the foundations of engagement at The Block and within the contexts of university museums and socially engaged practice. The essay offers a case study for developing engagement relationally, focusing on processes of collaboration with Aono and Watt and campus and community partners, drawing from in-depth post-facto interviews with the artists and other collaborators and participants.

Interviews with five participants and collaborators round out the publication. Northwestern University associate professor of performance studies Joshua Chambers-Letson weighs in from his perspective as an educator who incorporated the exhibition into his undergraduate course, "Introduction to Performance Studies," and as a scholar whose work places performance studies in conversation with a diverse set of fields including African American studies, Asian American studies, Latinx studies, art history, legal studies, and Marxist theory.

Melissa Blount, psychologist, community activist, and co-founder of M.E.E.T. (Making Evanston Equitable Together), discusses how participating in sewing circles with Marie Watt impacted her and was pivotal in her development of the Black Lives Matter Quilt project. Lisa Doi, a community activist who currently serves as president of the

Japanese American Citizens League's Chicago Chapter, reflects upon the experience of serving as a facilitator for a program anchored by intimate group discussions with Japanese American internment camp survivors.

Two other contributions come from Ninah Divine and Anna Takada, who became key partners on the project. At the time of *If You Remember*, Divine held the role of Coordinator, Native American and Indigenous Peoples steering group, Office of the President at Northwestern University. She became a central collaborator in developing projects with Marie Watt and creating connections to Native American organizations on campus and in Chicago. A graduate fellow in the Office of Multicultural Student Affairs, Takada was a key collaborator in developing connections to student life writ large and in working with Kristine Aono and Japanese American communities on and off campus. Both Divine and Takada speak to how their involvement with these projects intersected with their institutional roles and pre-existing personal commitments, while also offering critical reflections and insights on the process of collaboration in the museum context.

As references, the volume also includes a checklist of exhibited artworks and a full listing of programs. While no list can ever be comprehensive, we attempt to acknowledge the many people whose insights, energy, labor, and concerns contributed to this project.

The epigraphs by journalist Krista Tippett and writer and activist Audre Lorde that begin this text echo the way that each of the artists included in *If You Remember, I'll Remember* creates catalytic and poetic work that speaks to the role of art at the juncture of personal testimony and public commentary. Their work speaks to the usefulness of art and reminds us that poetry, broadly construed, is not a luxury. In *If You Remember*, the artists offer a guide to the ways in which they look at these inflection points in history. These histories—acts of endurance and resistance in times of incredible duress—continue to instruct us.

NOTES

1 Krista Tippett, *Becoming Wise: An Inquiry into the Mystery and Art of Living* (New York: Penguin Press, 2016), 122–123.

2 Audre Lorde, *Sister Outsider: Essays and Speeches* (New York: Crossing Press, 1985), 37.

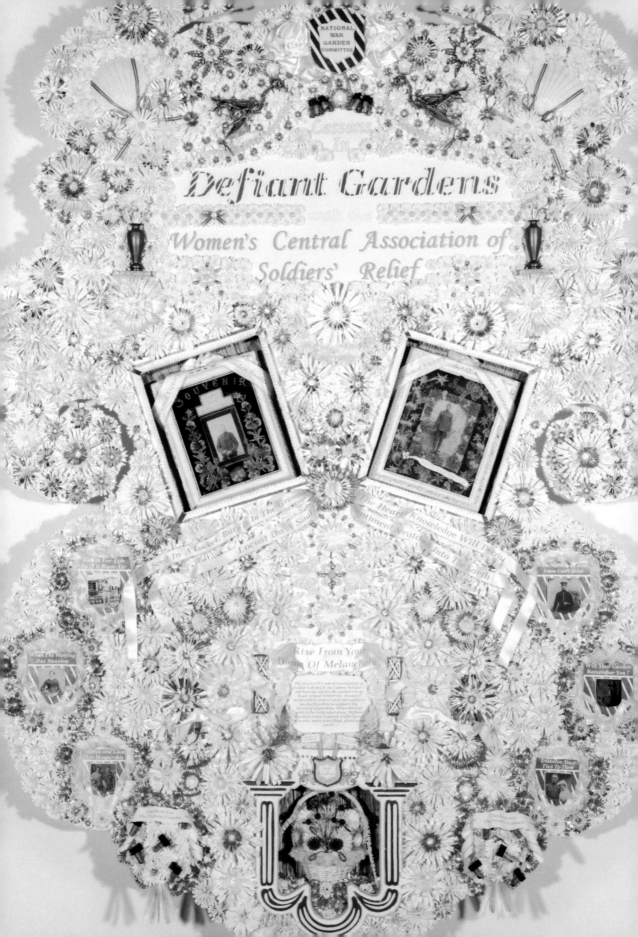

IF YOU REMEMBER, I'LL REMEMBER

Janet Dees

"What right do we have to forget? What do we owe to each other's memories?" —Dario Robleto

The title of the exhibition *If You Remember, I'll Remember* is borrowed from a 2013 essay of the same name by the artist Dario Robleto. Robleto's essay begins as a personal meditation on his failure to hold dear the memory of artworks he created in the past, and it builds to a broader philosophical prompt: "What right do we have to forget? What do we owe to each other's memories?"[1] Robleto's interest in actively engaging, preserving, and reflecting on the past echoes my own as well as that of the other artists selected for *If You Remember, I'll Remember*. The idea for *If You Remember, I'll Remember* was spawned by this longstanding preoccupation with the work of contemporary artists who engage with history and for whom archival research forms a foundation of their practice, heightened by a contemporary moment of socio-political unrest and urgency. The artist's ability to cast the past in new light often allows us to see things we didn't know existed and gain new understandings of the things we thought we knew. By engaging with historic documents, photographs, sound recordings, oral histories, and objects of material culture drawn from institutional and informal archives, the artists Kristine Aono, Shan Goshorn, Samantha Hill, McCallum & Tarry, Dario Robleto, and Marie Watt take up the themes of love, mourning, war, relocation, internment, resistance, and civil rights in nineteenth- and twentieth-century North America. The moments and events these artists explore are drawn primarily from the history of the United States, though they are often studied separately under the rubrics of war history, Native American, African American, and Asian American studies. My approach to the exhibition sought to honor the specificities of the

1 Dario Robleto, *Defiant Gardens*, 2009–10. Cut paper, homemade paper (pulp made from soldiers' letters home and wife/sweetheart letters to soldiers from various wars, cotton), thread and fabric from soldiers' uniforms of various wars, carrier pigeon skeletons, World War II–era pigeon message capsules, dried flowers from various battlefields, hair flowers braided by war widows, mourning dress fabric, excavated shrapnel and bullet lead from various battlefields, various seeds, various seashells, cartes de visite, gold leaf, silk, ribbon, wood, glass, foam core, glue. Collection of the Mint Museum, Charlotte. Gift of the Mint Museum Auxiliary, 2012.6. Image courtesy of the artist.

artworks and the histories in which they engage, while intending that their juxtaposition would reveal commonalities and points of intersection, provoking questions about how we approach and understand US history.

Artists' critical engagement with history is not a new phenomenon; neither is their interest in the archive as the handmaiden of history. While the practice can be located much earlier, the "archival impulse" of contemporary artists has been actively theorized and addressed in exhibitions and publications by artists, curators, and scholars since the 1990s to explore a diverse set of artistic practices.[2] Rather than critiquing the form and composition of archives or embracing an explicitly archival aesthetic, the artists in *If You Remember* mobilize archival materials to create labor-intensive, multi-layered, visually and materially seductive works. While their work may offer an implicit critique of the gaps in the way archival materials are read and interpreted, their respective approaches to the historical objects and documents that inform their work go beyond critique. Their work is imbued with a sincere desire to create art as a practice of remembrance. This active process is as much about memorialization, honor, and love as it is about keeping the past alive in the present so that we can understand how they are connected and learn lessons from history. The intimate and the personal are at play in each artwork in different ways, whether by the artists implicating themselves in the histories they have engaged, focusing on specific individuals' stories, or choosing materials and compositions that encourage viewers to engage in close looking. This emphasis on the intimate and the individual offers an empathetic point of entry.

Archival materials that inspired works in the exhibition include a class photograph of students at Pennsylvania's Carlisle Indian Industrial School; documents from a Chicago family relating to the early history of the 16th Street Baptist Church in Birmingham, Alabama; a photograph of an early-twentieth-century potlatch off Vancouver Island; the letters of soldiers who served in various wars in which the United States was engaged; and the testimonies of Japanese American internment camp survivors, among others. It was coincidental that 2017, the year in which *If You Remember, I'll Remember* would be presented to the public, would also mark important anniversaries of historic events related to the subjects taken up by these artists. February 19, 2017, marked the seventy-fifth anniversary of Executive Order 9066, which ordered the wartime internment of over 120,000 Japanese American citizens and residents living on the West Coast of the United States.[3] June 12, 2017, marked the fiftieth anniversary of the Supreme Court's decision in *Loving v. Virginia*, which found laws prohibiting interracial marriage—then in effect in sixteen states—unconstitutional.

If You Remember was conceived at the end of 2015, when the historical moments explored by the artists in the exhibition strongly resonated with the socio-political condition of that time. This condition can best be evoked by remembering a series of events that happened between June and December of 2015. On June 17, 2015, self-proclaimed white supremacist Dylann Roof shot and killed nine members of the Emanuel African Methodist Episcopal Church in Charleston, South Carolina, while they were attending a prayer service. In contrast to this, nine days later on June 26, the US Supreme Court announced its decision in the case *Obergefell v. Hodges*, guaranteeing the right to same-sex marriage in all fifty states. This was the culmination of a long battle and recalled the Supreme Court ruling made almost fifty years before in *Loving v. Virginia*. On November 13, coordinated terrorist attacks in Paris took the lives of over 120 people. On the 24th of the same month, closer to my home in Chicago, the full video footage of the police action killing of Laquan McDonald was released.[4] This sparked massive protests in alignment with the Black Lives Matter protests that had been ongoing since 2013, disrupting commerce on Chicago's Magnificent Mile.[5] On December 2 in San Bernadino, California, the attack by married couple Syed Rizwan Farook and Tashfeen Malik resulted in the loss of fourteen lives and injury to over twenty other individuals. The fact that Farook had been born in the United States and was a US citizen at the time of the attack provoked public discussion about "home-grown terrorism" and a debate about profiling and targeting Muslim residents and citizens in the interest of national security.[6] The anti-Muslim rhetoric evoked the sentiment that led to the internment of Japanese American residents and citizens during World War II.[7]

Recalling earlier US histories, this series of events resurfaced violence, racial terror, xenophobia, and prejudice in the public consciousness. This period also highlighted the way in which people are able to mobilize when they are determined to have their voices heard and their lives valued. In alignment with mobilizations for social justice, *If You Remember, I'll Remember* consisted of a constellation of artworks that created a space for reflecting on these pressing contemporaneous concerns by taking a step back to consider them within the longer of arc of US history.

MOURNING

Mourning and emotional loss connect the work of Dario Robleto and Samantha Hill. Initiated during the aftermath of the September 11 attacks, Dario Robleto's *War Series* (2001–10) is a meditation on the intimate and personal dimensions of loss that are experienced as a result of war. As a foundation for this series of works, Robleto

conceived a narrative of a time-traveling soldier who visited battlefields in every war in which the United States had been involved during its over-200-year history. With this conceptual framework as a reference, Robleto created sculptures that represented condensed moments of what this soldier would have experienced.[8] Two works from this series, *No One Has A Monopoly Over Sorrow* (2004) [FIG 2] and *Defiant Gardens* (2009–10) [FIGS 1, 3], were included in *If You Remember, I'll Remember.* Robleto's poetic sculptures reform and repurpose historic material, emphasizing the labor of remembering and the bonds of love that work implies. Drawing on elements from the Civil War to recent conflicts in Iraq and Afghanistan, Robleto's works speak to the conditions of love and loss in wartime. Rather than focusing on any one war in particular, Robleto's work evokes the continuous cycle of loss and mourning that accompanies war and that is experienced by all who are associated with it, regardless of affiliation.

The carefully crafted material descriptions that accompany the works are integral—not supplemental—to them, revealing layers of meaning embedded in the densely constructed intimate sculptures. For example, *No One Has A Monopoly Over Sorrow* takes the form of a basket of dried flowers enclosed in a vitrine. Only up close can one see

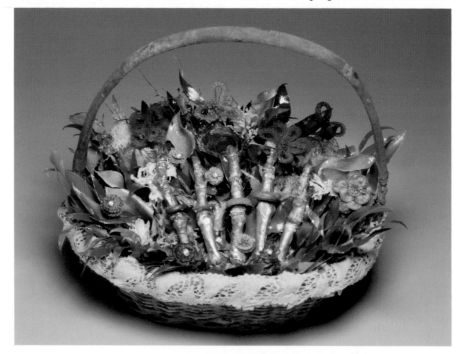

2 Dario Robleto, *No One Has A Monopoly Over Sorrow*, 2004. Men's wedding ring, ring-finger bones coated in melted bullet lead from various American wars, men's wedding bands excavated from American battlefields, melted shrapnel, wax-dipped preserved bridal boutiques of roses and white calla lilies from various eras, dried chrysanthemums, male-hair flowers braided by a Civil War widow, fragments from a mourning dress, cold-cast brass, bronze, zinc, and silver, rust, mahogany, glass. Courtesy of the artist.

that there are finger bones encircled with wedding rings intertwined with the flowers. From the work's description we learn that these are "[m]en's wedding-ring finger bones coated in melted bullet lead from various American wars" and "men's wedding bands excavated from American battlefields," and that the flowers are "wax-dipped preserved bridal bouquets [...] from various eras" and "male-hair flowers braided by a civil war widow" with "fragments from a mourning dress." *No One Has A Monopoly Over Sorrow* was inspired in part by the Robleto's discovery that World War I was the first war in which the technology of devastation was so complete that bodies were left unidentified on the battlefield. What remained then became the object of mourning for all who lost loved ones in the war: "One wedding ring had to become everybody's ring."[9]

In the work *Defiant Gardens*, the artist combines and transforms symbolically charged items such as soldiers' love letters, war widows' hair flowers, and seeds and shrapnel to create a poetic statement that is more than the sum of its parts [FIGS 1, 3].[10] *Defiant Gardens* refers to the cultivation of gardens by soldiers and embattled civilians during wartime—life-affirming acts in the face of traumatic conditions. Created in the form of an oversized wreath, the work evokes both the material culture of mourning and the verdant abundance of a garden. Robleto uses material and metaphor to conjure the complexities of love, loss, resilience, and mourning embedded in the experience of war.[11]

The ways in which personal narratives intersect with moments of historical importance have long been a preoccupation of Chicago-based artist Samantha Hill. Since 2009 Hill has been developing the Kinship Project archive, a repository comprising oral histories and over 3,000 objects—including vintage photographs and scrapbooks mostly from African American families—obtained primarily through Hill's in-depth engagement with various

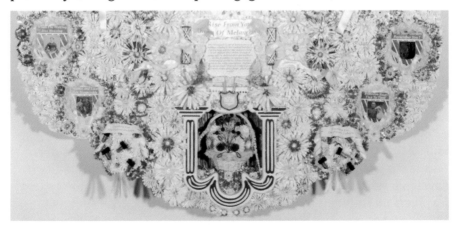

3 Dario Robleto, *Defiant Gardens* (detail), 2009–10. See FIG 1 for complete caption.

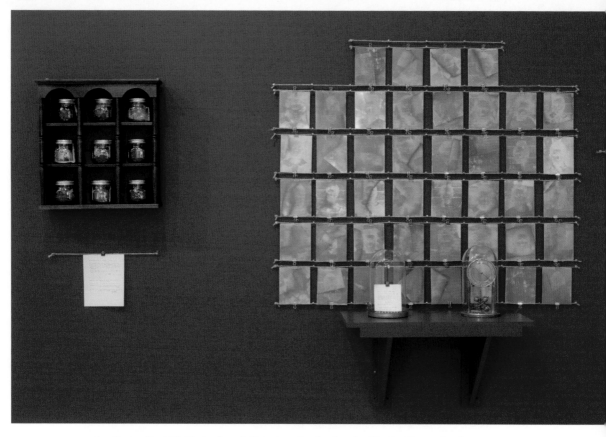

4 Samantha Hill, *Herbarium: A historic reflection inspired by the Mason family collection* (detail, "Altar for Children"), 2015–17. Tintype installation. Installation view at The Block Museum of Art, 2017.

communities in the United States, particularly those in Anchorage, Charlotte, and Chicago. These artifacts then become the inspiration for Hill's public interventions, performances, and multimedia installations, which address historical and contemporary American social issues. This impulse to collect photographs in order to engage with history was inspired by Hill's desire to preserve her own family's histories.[12]

Herbarium (2015–17), the first iteration of which was exhibited at the Hyde Park Art Center in 2015, was inspired by a collection of family artifacts dating from 1839 to 1940, given by a family from the Hyde Park neighborhood of Chicago to the Kinship Project. The collection contains newspaper clippings, letters, and other documents related to family history and political events in the South. Hill was particularly drawn to an herbarium—a journal for the scientific study of plants— and documents related to one of the family's ancestors, Ulysses Grant Mason (1872–1933), an African American physician and community developer who lived in Birmingham, Alabama. Hill uses Mason's early involvement in Birmingham's 16th Street Baptist Church (founded in 1873) as an entry point to explore the church's history. In particular, Mason assisted with efforts to develop the church's current building,

which was completed in 1911. The church became a nationally charged site in 1963 when members of the Ku Klux Klan bombed it, killing Addie Mae Collins (aged 14), Carol Denise McNair (aged 11), Carole Robertson (aged 14), and Cynthia Wesley (aged 14). Hill connects this history to more recent incidents of racially charged violence. Employing the veiled language of Victorian flower symbolism within this installation, she alludes to the perpetual state of mourning that such losses may engender.

This is most evident in the section of *Herbarium* that Hill refers to as the "Altar for Children" [FIG 4], which consists of a grid of tin-types printed with a process that creates ghostlike images that reveal themselves as portraits as viewers change their position in relationship to the works. On a shelf located beneath the photographs lies a glass cylinder covering a single typewritten sheet of paper that functions as a memorial for African American children killed as a result of racially inflected violence. Under the heading "Plant description: Mixed Zinnia," Hill lists "Birmingham, Alabama, Sept. 15th, 1963" followed by the names and ages of the four girls killed in the 16th Street Baptist Church bombing. The list continues with "Sanford, FL: Feb. 26th, 2012, Trayvon Martin (Age 17)" and "Ferguson, Missouri: Aug. 9th, 2014, Michael Brown (Age 18)" [FIG 5]. The inclusion of the phrase "Plant Description: Mixed Zinnia" refers to the Victorian Flower Code, a key to which was given to visitors as a handout. In this case "Mixed Zinnia" equates to "Thinking (or in memory) of an Absent Friend," signaling the artist's emotional response to the deaths of these young people.

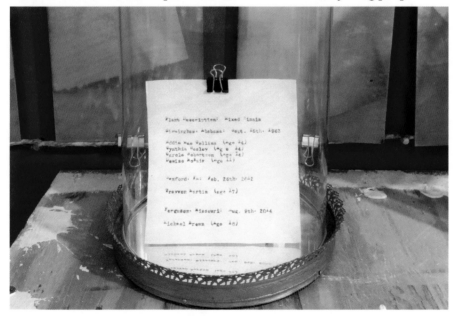

5 Samantha Hill, *Herbarium: A historic reflection inspired by the Mason family collection* (detail, bell jar), 2015–17.

This engagement with the lives, deaths, and perspectives of children is a leitmotif that appears in other parts of Hill's installation as well as other works in the exhibition, including Shan Goshorn's *Prayers for Our Children* (2015), Marie Watt's *Witness* (2015), and Kristine Aono's *The Nail That Sticks Up the Farthest...* (2017).

I REMEMBER WHEN

The focus on African Americans' struggle for equality engaged by Hill's *Herbarium* and the bonds of love and marital intimacy invoked by the wedding bands in Robleto's *No One Has A Monopoly Over Sorrow* are echoed in McCallum & Tarry's *Exchange* (2007). *Exchange* is one of several self-portrait video works produced by the artist couple Bradley McCallum and Jacqueline Tarry between 2004 and 2010, exploring their relationship to each other in conversation with larger historical and social factors [FIG 6].[13] The work features the artists—who were married at the time—engaged in a mutual blood transfusion. McCallum is white and Tarry is Black, so while the exchange of blood can represent the solidification of an intimate bond or an oath of loyalty, here it also references the "one-drop rule" and the complex history of laws and customs governing race and interracial relationships in the United States. The Supreme Court's 1967 decision in *Loving v. Virginia* found laws prohibiting interracial marriage—then in effect in sixteen states—unconstitutional.[14] The couple's gesture is made even more poignant by the fact that the ruling was made during the artists' lifetimes.

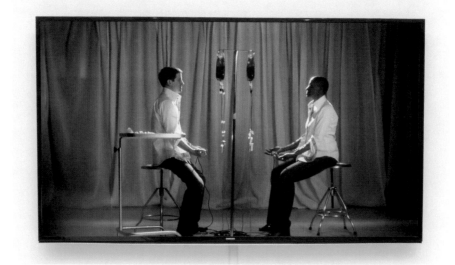

6 McCallum & Tarry, still from *Exchange*, 2007. HD video with sound, 3:46 minutes. Direction, cinematography, and editing: Gavin Rosenberg; audio: Brian Harnetty. Installation view at The Block Museum of Art, 2017.

The soundtrack for *Exchange* includes excerpts from archival recordings relating to African American history and civil rights in the American South, including the phrase "I remember when..." taken from a 1941 interview with an elderly African American woman from Alabama recalling the end of the Civil War when she was a child; field recordings of officers' boots striking the pavement during the March 7, 1965, march across the Edmund Pettus Bridge in Selma, Alabama, which came to be known as "Bloody Sunday"; and an excerpt from a June 23, 1964, telephone conversation between Senator John Eastland of Mississippi and President Lyndon B. Johnson regarding the disappearance of three civil rights workers, in which the senator told Johnson that he thought it was "a publicity stunt" (the workers—James Chaney, Andrew Goodman, and Michael Schwerner—were later found to have been murdered by the Ku Klux Klan). The droning, insistent soundtrack of *Exchange* floated throughout the gallery, becoming the sonic backdrop for the entire exhibition.[15]

WITNESSING

While all of the works in *If You Remember, I'll Remember* are about bearing witness to the past, Marie Watt's *Witness* (2015) and Kristine Aono's *The Nail That Sticks Up the Farthest...* (2017) most directly engage this theme. The potential of everyday objects to spark memory and inspire narrative is at the heart of Watt's practice, which is heavily influenced by Indigenous—particularly Seneca—principles, biographies, oral tradition, and history, while highlighting cross-cultural connections and understandings. The wide-ranging functions and associations of blankets, including the practice of gifting blankets to those who have witnessed important events in Seneca culture, have made them a potent material for the artist.

The suite of works *Witness* (2015), *Transportation Object (Letter Ghost)* (2014), and *Transportation Object (Potlatch)* (2014) by Watt is taken from a larger series and was inspired by a photograph that Watt encountered in the Royal British Columbia Museum and Archives.[16] The photograph depicts a 1913 Quamichan potlatch near Vancouver Island [FIG 8]. One of the key aspects of the potlatch—a complex and multifaceted tradition—is the redistribution of wealth within the community. Watt was struck by the fact that the potlatch could be interpreted as an act of civil disobedience; indeed, these ceremonial gatherings were banned by the Canadian and US governments from the 1880s to the 1950s.[17] In *Witness*, Watt reinterpreted the image at cinematic scale by embroidering it onto a vintage double-length trade blanket and inserting a portrait of herself and her daughters in the foreground as contemporary witnesses to the historical event, making an explicit connection between past and present [FIG 7]. Though Watt is

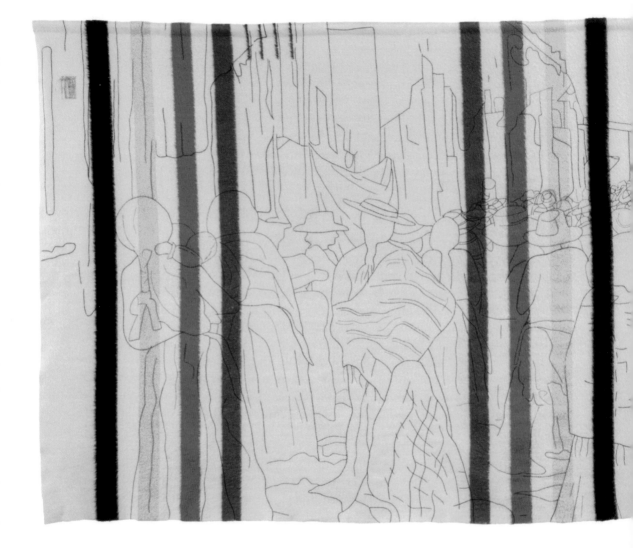

7 Marie Watt, *Witness*, 2015. Reclaimed wool blanket, embroidery floss, thread.
Collection of Jordan Schnitzer Museum of Art, University of Oregon, Eugene, OR.

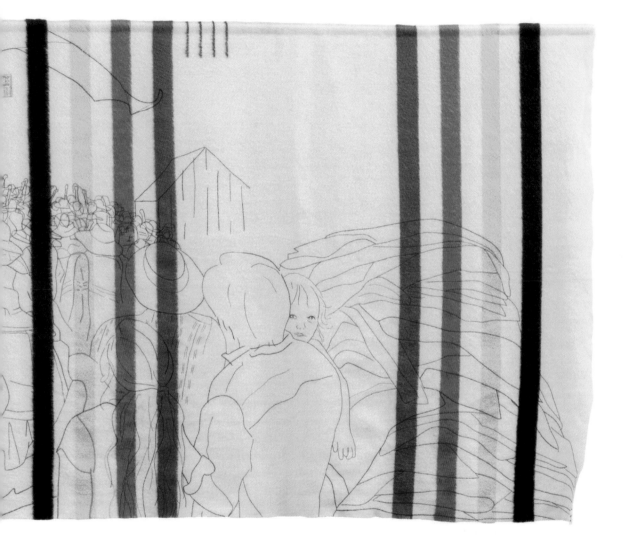

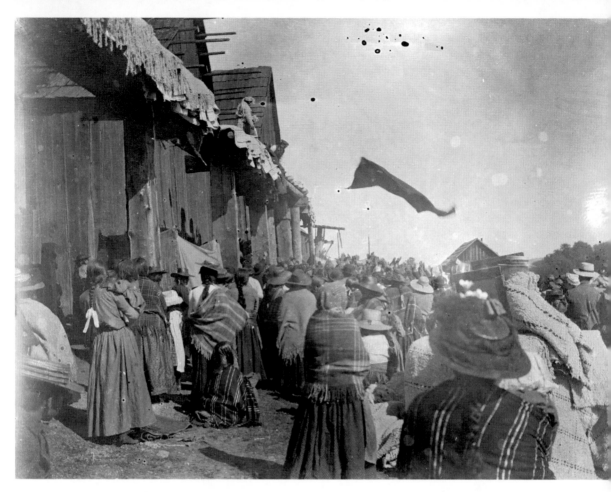

8 Quamichan Potlatch, Coast Salish, 1913. Photograph by Reverend Tate. Image PN1500. Courtesy of the Royal BC Museum and Archives.

Seneca, she grew up in the Pacific Northwest, where her mother was involved in Native American education and which connected her to people from diverse Native communities. The potlatch that she bears witness to in this work is not unlike contemporary gatherings that she has attended with her daughters.

Watt credits the Black Lives Matter movement as an influence on some of her compositional choices. The phrase "Hands Up, Don't Shoot"—the purported last words of Michael Brown—became a BLM rallying cry, accompanied by the gesture of raised hands. In the original photograph upon which *Witness* is based, outstretched hands reach for the blanket that has been thrown from a roof by the potlatch's host family. Watt exaggerated these hands to mimic gestures of protest, connecting this past moment of civil disobedience with present activism, invoking solidarity across causes and cultures.

The work of Kristine Aono, a third-generation Japanese American, is often influenced by her family's history and her interest in questioning narratives about race, acculturation, and cultural identity.[18] Aono's *The Nail That Sticks Up the Farthest...* was created

for *If You Remember* and is a reprisal of her 1992 installation *Deru Kugi Wa Utareru (The Nail That Sticks Up the Farthest Takes the Most Pounding)*, which was commissioned for the exhibition *Relocations and Revisions: The Japanese-American Internment Reconsidered* at the Long Beach Museum of Art in California. The title is drawn from a Japanese proverb promoting the virtue in prioritizing group-belonging over individual concerns, but to the American ear, it can signal the precarious position of those who stand out. The work memorializes and calls attention to the internment during World War II of 120,313 Japanese American residents—two-thirds of whom were US-born American citizens—living on the West Coast of the United States. Aono's parents and grandparents were among those interned.[19]

Forty-five feet in length and over ten feet tall, *The Nail That Sticks Up the Farthest...* is immersive and interactive [FIGS 9, 10, 11]. The installation includes copies of the testimonies of former internees given during the 1981–83 Commission on Wartime Relocation and Internment of Civilians. Convened in part due to pressure put on the United States by various Japanese American organizations, the commission recommended reparations to survivors of the camps. These documents are interwoven with copies of a letter to the artist from her grandfather that alludes to his internment experience and life afterward.

A grid of 120,313 holes punctured in the wall—one for each individual interned—was overlaid on these documents. Aono created the design of the American flag by inserting rusted nails into about half the holes. The flag references the American flag that Aono's maternal grandfather used to hang outside of the gift shop he owned in Fresno, California. It was one of the only possessions from the store he was able to take with him to the camps in Jerome and Rohwer, Arkansas, where he was interned. He brought the flag with him when he relocated to Chicago after the end of the war and kept it until the end of his life. A passage in one of his letters that is included in the installation recounts this story: "When I closed the store, they ordered me not to take anything from closed store. I asked if I could take the American flag which I used for holiday, he said it was alright. I kept it for memory..." [FIG 10]. In the context of *The Nail That Sticks Up the Farthest...*, the flag is an ambivalent sign: a symbol of the patriotism professed by Aono's grandfather and also of the governing body under which the incarceration of law-abiding residents and citizens was enacted.

Visitors were invited to honor those who were interned by adding nails to fill out the grid.[20] As the weeks passed these interventions began to transform the appearance of the work. The performative act of adding to this wall was a powerful experience that is explored in depth in other contributions to this volume. Some visitors added to

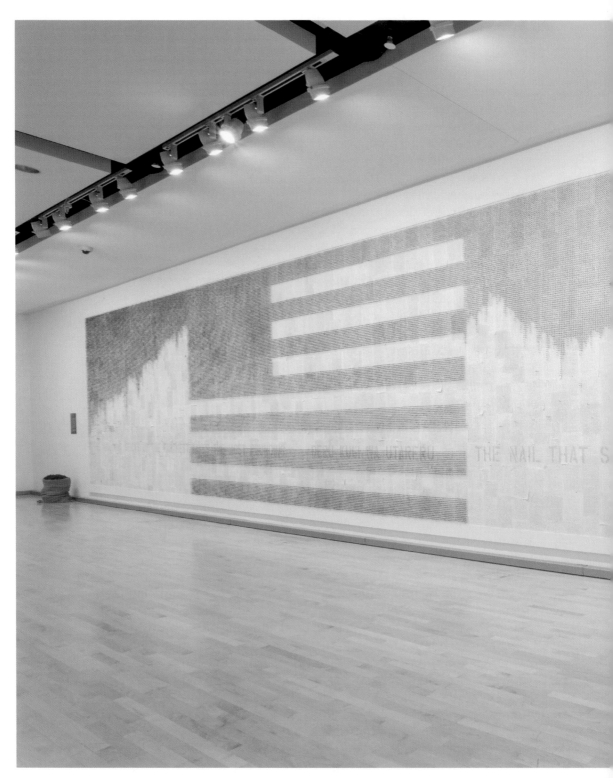

9 Kristine Aono, *The Nail That Sticks Up the Farthest...*, 2017.
Mixed media installation. Installation view at The Block Museum of Art, 2017.

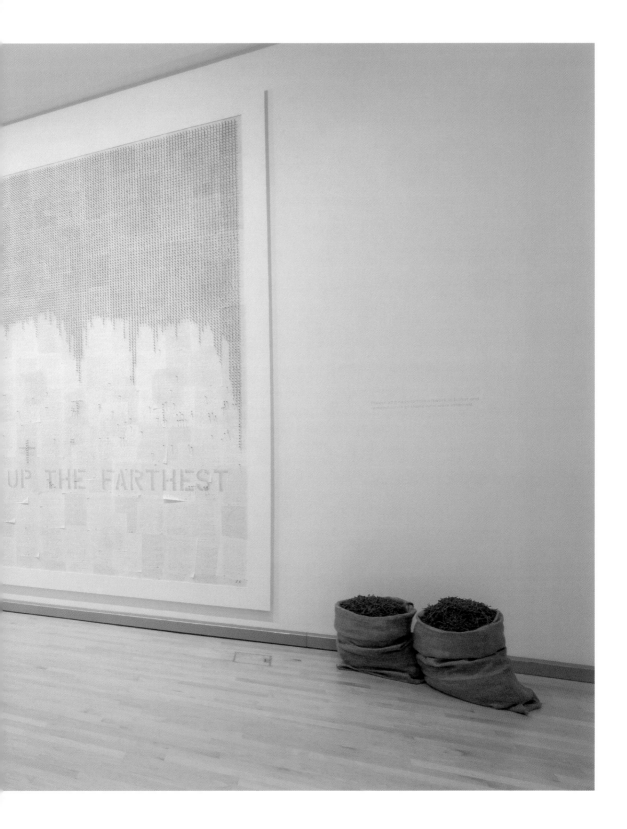

UP THE FARTHEST

10 Kristine Aono, *The Nail That Sticks Up the Farthest...* (detail), 2017.

the grid in a straightforward fashion. Others took the time to write out words or phrases like "love" and "Resist Persist" that spoke to the history addressed by the work and to the political situation happening outside of the museum walls [FIG 11].

HISTORIES OF REMOVAL

The specter of forcible relocation that haunts Aono's work also informs the works of Shan Goshorn. After many years of working primarily as a painter and photographer, the Eastern Cherokee artist and activist turned to basket weaving in 2008 as her primary mode of expression. Goshorn's conceptual baskets combine Cherokee aesthetics with thought-provoking content—including historical photographs and texts—to address the links between historical events and ongoing struggles for Native American sovereignty and self-determination.

The fraught history of treaties between the US government and several Native American nations is one focus of *Cherokee Burden Basket: A Song for Balance* (2012) [FIGS 12, 13]. This work specifically references the history of the Cherokee Nation and in particular the 1835 Treaty of New Echota, in which the Cherokee purportedly agreed to leave their territory in North Carolina for land in Oklahoma. The majority of Cherokee protested, claiming the treaty was invalid because the men who signed it on behalf of the Cherokee were not authorized to do so.[21]

The paper splints from which the basket is woven are printed with excerpts from historical documents including the Treaty of New

Echota, the Indian Removal Act of 1830, and the mission of the Carlisle Indian Boarding School [FIG 13].[22] The work makes explicit connections between historical events and the continued use of racial slurs and the appropriation of Native American names and terms in commercial products and sports teams' names and mascots. The artist's choice of the burden basket form underscores the weight these issues continue to have for Native peoples. In *Cherokee Burden Basket* these burdens are metaphorically acted upon by being interwoven with elements deemed healing—including the words of Cherokee morning and evening songs, performed to open and close the day in a balanced way.

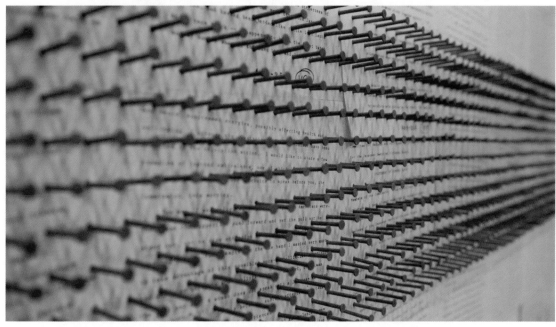

11 Kristine Aono, *The Nail That Sticks Up the Farthest...* (detail, with addition of nails by museum visitors), 2017.

A photograph from the Smithsonian Institution's National Anthropological Archives, showing students at the Carlisle Indian Industrial Boarding School, is the basis for the work *Prayers for Our Children* [FIG 14]. In operation from 1879 to 1918, Carlisle served as the model for approximately 150 boarding schools across the United States that sought to assimilate Native American children through a process of forced acculturation. Interwoven with the photograph are the names and cultural affiliations from the student roster of over 10,000 children who attended Carlisle as well as prayers of healing and well-being in the Navajo, Lakota, Kaw, and Cherokee languages and the words to a memorial song: "We remember your sacrifices. You will not be forgotten."

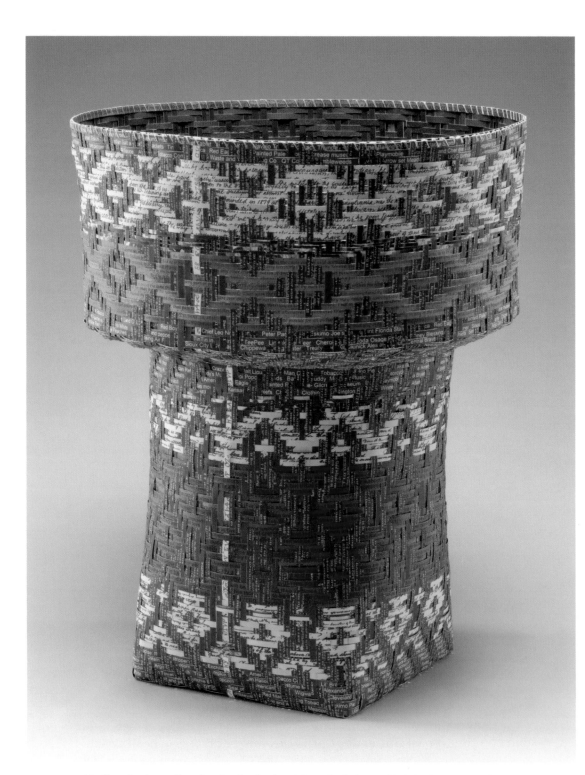

12 Shan Goshorn, *Cherokee Burden Basket: A Song for Balance*, 2012. Arches watercolor paper, archival inks, and acrylic paint. Mary and Leigh Block Museum of Art, Northwestern University, purchased with a gift from Sandra Lynn Riggs and members of the Block Leadership Circle, 2017.3.

EPHEMERAL MONUMENTS

In addition to the work *Witness*, Marie Watt was commissioned to create a new piece for the exhibition. Many of Watt's larger works are created through community participation, including by the informal network of friends and colleagues connected to her Portland, Oregon, studio as well as visitors to the museums and art spaces in the various places where she exhibits her work. In the past, this participation has taken several forms, including sewing circles and the donation of blankets and their associated stories. Sewing circles are open to anyone, "no experience necessary." Participants contribute their stitches and receive a print from the artist in return. These important material contributions inform the way the works evolve once Watt returns to her studio. Equally important is that the sewing circles become forums for conversation and sharing with the potential to connect people on various levels. In this way the events become arenas for exchange that underscore the value of the formal and informal oral transmission of knowledge.

Watt's new work was to be informed in part by the artist's visits to Northwestern University, partially created through local community participation in the form of sewing circles, developed and completed in her Portland studio, and installed in the museum half–way through the run of the exhibition. The process of collaboration and conversation between Watt and campus and community members is explored in depth in the essay "The Imprint of Exchange" in this volume. Here I focus attention on the conceptual and formal concerns

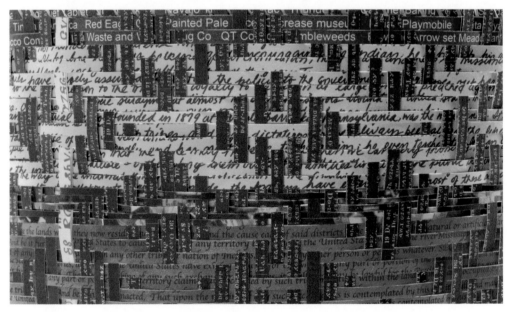

13 Shan Goshorn, *Cherokee Burden Basket: A Song for Balance* (detail), 2012.

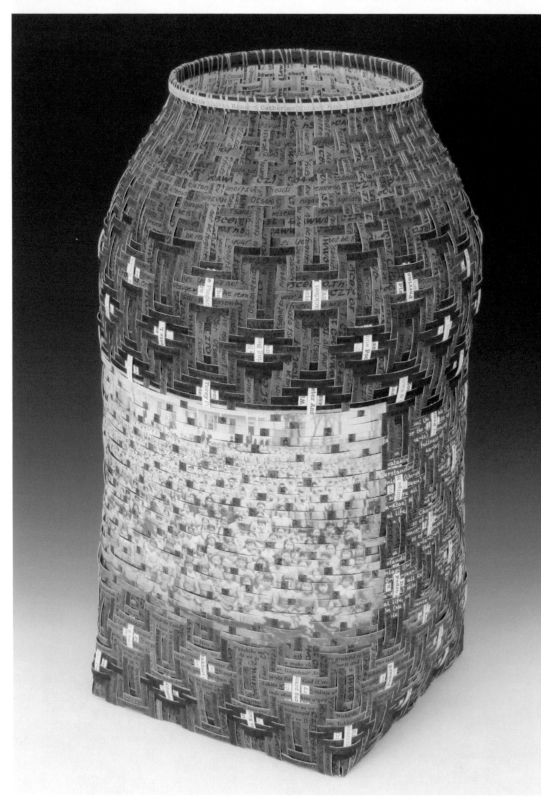

14 Shan Goshorn, *Prayers for Our Children*, 2015. Arches watercolor paper splints printed with archival inks, acrylic paint.

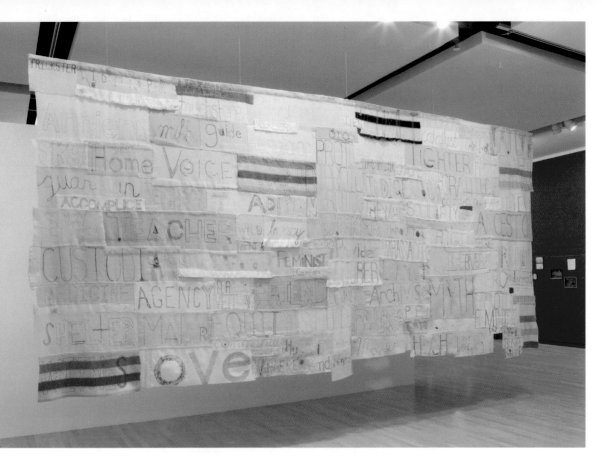

15 Marie Watt, *Companion Species: Ferocious Mother and Canis Familiaris*, 2017.
Installation view at The Block Museum of Art, 2017.

of the resultant works *Placeholder* (2017) and *Companion Species: Ferocious Mother and Canis Familiaris* (2017).

Companion Species: Ferocious Mother and Canis Familiaris used as a starting point the symbiotic relationship between humans and animals, particularly those from the genus *Canis*, which includes both wolves and domestic dogs [FIG 15]. This work is part of a new series and is influenced by Indigenous, American, and European traditions in which these animals relate to humans as teachers, nurturers, and protectors. *Companion Species: Ferocious Mother and Canis Familiaris* is Watt's first large-scale work to consist solely of text and appropriates the visual language of handmade protest signs. This aesthetic and conceptual choice connects the work to the signs that were used during contemporaneous Black Lives Matter, Dakota Access Pipeline, and Women's March protests.[23] The work consists of words generated through research, conversations with campus and community members during Watt's visit to Northwestern, and free association that used the above-mentioned traditions and the nature of relating in that socio-political moment as starting points. Words like "ally," "organizer," and "solidarity" most directly evoke the feeling of protest [FIG 16].

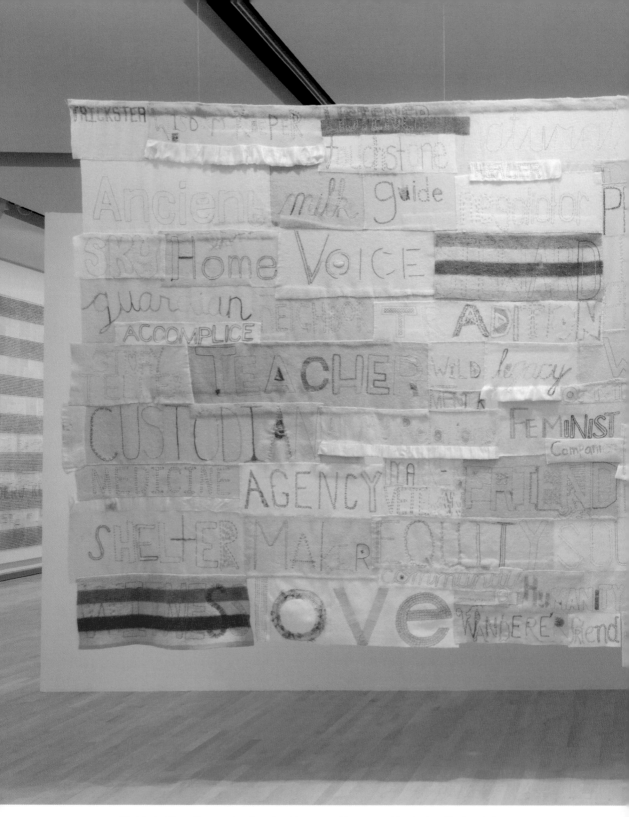

16 Marie Watt, *Companion Species: Ferocious Mother and Canis Familiaris*, 2017.
Installation view at The Block Museum of Art, 2017.

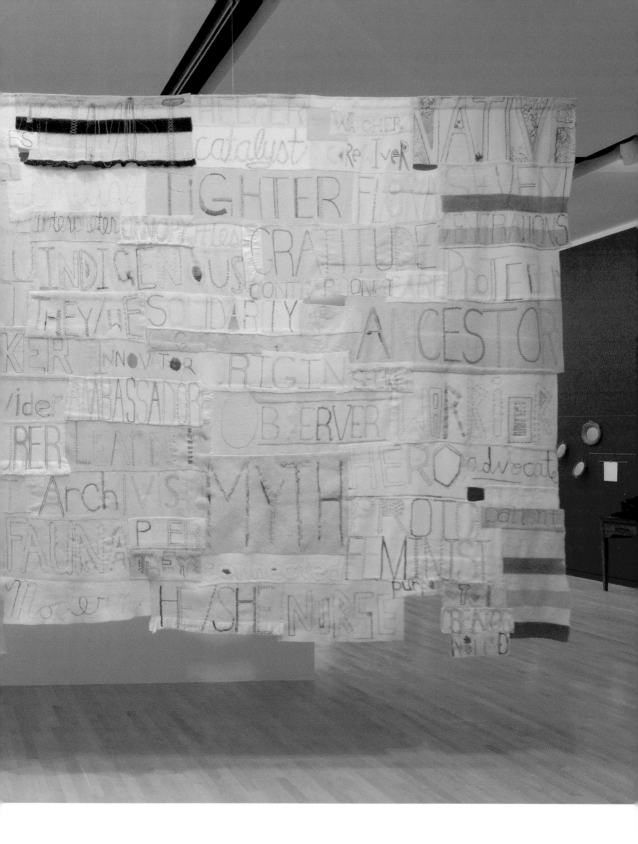

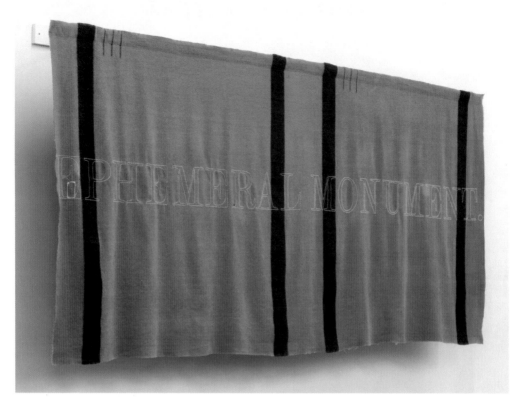

17 Marie Watt, *Placeholder*, 2017. Reclaimed wool blanket, transparent glass Czech seed beads, thread. Private collection, Oakland, CA.

Placeholder (2017) was created with the intention of installing the work at the beginning of the exhibition and replacing it halfway through the run of the exhibition by *Companion Species: Ferocious Mother and Canis Familiaris,* but due to logistical considerations, it was not installed [FIG 17]. Its genesis is based in research Watt undertook as she considered the specific place of Northwestern University and the greater Chicago area. Watt's ongoing exploration of Native American history and enduring presence in Chicago and the Great Lakes region, plant knowledge, and water as a multivalent resource also informed the development of the work. These interests found resonance as Watt engaged in conversations with Northwestern students, faculty, staff, and other members of the greater Evanston and Chicago communities. Watt continued to investigate these themes through oral histories and archival research.

Placeholder features the words "ephemeral monument" sewn in Czech glass beads on a two-tone trade blanket that is reminiscent of Watt's *Witness.* The phrase was drawn from Watt's reading of Native American Studies scholar John Low's work about the history of the Potawatomi in what is now Chicago. Low uses the term to describe non-permanent and often performative acts that the Potawatomi used to preserve their culture in the late nineteenth century.[24] With *Placeholder*—as with her other works and those of other artists in the

exhibition—Watt makes the ephemeral concrete and tangible, an act that keeps alive histories that may be under threat of erasure.

WHY THE PAST STILL MATTERS TODAY

If You Remember, I'll Remember opened two weeks after the inauguration of Donald Trump as the 45th president of the United States. One of the most contentious elections in recent memory, it was marked by several national and international protests.[25] The themes explored in the exhibition took on new urgency for many people in a way that I could not have predicted when I initiated the project in 2015; however, the foundational premise of the exhibition was that these various struggles for civil rights are recursive features of our history. This atmosphere of polarization in the United States increased over the exhibition's four-and-a-half-month run and shaped the lenses through which visitors encountered the works in the exhibition. "Powerful with much resonance to today's political climate," read one comment card, a succinct summary of many of the written responses the museum received about the exhibition.[26] However, one comment stood out from the rest and signals to me the work that stills needs to be done: "Very interesting! I am just concerned that, the progressive agenda being what it is, Japanese internment will be used somehow to protect Muslims. There is little connection as the Japanese were not violent, and had no religion to impose."[27]

Toward the end of Robleto's essay *If You Remember, I'll Remember*, he invokes the work of all of those who labor to keep historical objects intact. "The very human desire to want to slow the tide of erosion is confronted daily by the conservator through the chemistry of decay, the historian by reclaiming original context and knowledge, and by the contemporary artist who must argue why the past still matters today…. This small team may labor away but ultimately it is up to all of us, the viewers, to finish this work of historical repair."[28] The exhibition *If You Remember, I'll Remember* was offered as a small contribution to the process of historical repair, aimed at keeping history alive so that we may learn from the mistakes and draw inspiration from the resilience of those who have come before in order to enact change in the present.

In memory of
Reverend Lloyd E. Dees (1930–2016)
and
Shan Goshorn (1957–2018)

NOTES

1 Dario Robleto, "If You Remember, I'll Remember," in *Disembodied Portraits: Portrait Miniatures and Their Contemporary Relatives* (Cleveland: Cleveland Museum of Art, 2013). Also accessible on the artist's website at www.dariorobleto.com.

2 See for example: Ingrid Schaffner and Matthias Winzen, *Deep Storage: Collecting, Storing, and Archiving in Art* (New York: Prestel, 1998), published in conjunction with the exhibition of the same name, presented at PS 1 Contemporary Art Center, New York, and the Henry Art Gallery, Seattle; Hal Foster, "The Archival Impulse," *October* 110 (Autumn 2004): 3–22; Charles Merewether, ed., *The Archive* (Cambridge, MA: The MIT Press, 2006); Mark Godfrey, "The Artist as Historian," *October* 120 (Spring 2007): 140–71; Nato Thompson, *Ahistoric Occasion* (Northampton, MA: MASS MoCA, 2007); Okwui Enwezor, *Archive Fever: Uses of the Document in Contemporary Art* (New York: International Center for Photography, 2008); and Dieter Roelstraete, *The Way of the Shovel: On the Archaeological Imaginary in Art* (Chicago: Museum of Contemporary Art Chicago and University of Chicago Press, 2013).

3 Executive Order 9066 was issued by US President Franklin D. Roosevelt on February 19, 1942. It initiated the removal from the West Coast and incarceration of over 120,000 Japanese Americans for the duration of World War II, https:// www.archives.gov/historical-docs/ todays-doc/?dod-date=219.

4 McDonald was a seventeen-year-old unarmed African American man who was killed in a police action shooting in Chicago in October of 2014. Jason Van Dyke, the officer who killed McDonald, was found guilty of second degree murder in October 2018.

5 The death of Trayvon Martin (February 2012) and the subsequent acquittal of George Zimmerman, the civilian who killed him (July 2013), served as the spark for igniting the development of the Black Lives Matter movement. The killings of Eric Garner in New York (July 2014), Michael Brown in Ferguson, MO (August 2014), Tamir Rice in Cleveland, OH (November 2014), Freddie Gray in Baltimore, MD (April 2015), and others served as lighting rods for the continued protests.

6 See for example Andrew Gumbel, "San Bernardino Shooting: US Divided Over Whether Attack Was Terrorism," *Guardian*, December 4, 2015, https:// www.theguardian.com/us-news/2015/ dec/04/san-bernardino-shooting- america-divided-terrorism.

7 An incident that occurred further along in the exhibition planning process succinctly captured this sentiment. In November 2016, Carl Higbie, a prominent backer of newly elected US President Donald Trump, pointed to Japanese-American internment as precedent for a potential registry for Muslim residents and citizens. See Derek Hawkins, "Japanese American Internment Is 'Precedent' for National Muslim Registry, Prominent Trump Backer Says," *Washington Post*, November 16, 2016, https://www.washingtonpost.com/ news/morning-mix/wp/2016/11/17/ japanese-internment-is-precedent- for-national-muslim-registry- prominent-trump-backer- says/?noredirect=on&utm_ term=.1bb4a20e02ec. Representative Mark Takano of California was outspoken in his rebuff of Higbie's comments: "Opinion: Japanese American Incarceration 'Unforgivable Policy' Not Precedent," NBCnews. com, November 29, 2016, https://www. nbcnews.com/news/asian-america/ opinion-japanese-american- incarceration-unforgivable-policy-not- precedent-n689666.

8 Dario Robleto, *If You Remember, I'll Remember* Opening Conversation, February 4, 2017, The Block Museum of Art, https://vimeo.com/203555783.

9 Ibid.

10 For historical context on the specific conditions in which these gardens were developed, see Kenneth I. Helphand, *Defiant Gardens: Making Gardens in Wartime* (San Antonio, TX: Trinity University Press, 2006). Robleto's *Defiant Gardens* was originally commissioned by the Museum of Contemporary Art Denver for the exhibition *Dario Robleto: An Instinct Toward Life* and was produced in collaboration with the Center for the Study of War Experience at Denver's Regis University. See Nora Burnett Abrams, *Dario Robleto: An Instinct Toward Life* (Denver: Museum of Contemporary Art Denver, 2011).

11 For more on this phenomenon, see "Trench Gardens: The Western Front in World War I," in Kenneth I. Helphand, *Defiant Gardens: Making Gardens in Wartime*, 21–59.

12 Katherine Balcerek, "Art and History Collide: An Interview with Samantha Hill," Knight Foundation website, October 31, 2013, https://knightfoundation.org/articles/at-and-history-collide-an-interview-with-samantha-hill.

13 Janet Dees, "Poetry Is Not a Luxury: McCallum & Tarry's Self-Portraits," unpublished essay 2011, to be included in forthcoming volume *McCallum Tarry: Intersections*, to be published by the Burchfield Penney Art Center, Buffalo, NY.

14 Peggy Pascoe, "Miscegenation Law, Court Cases, and Ideologies of 'Race' in Twentieth Century America," *Journal of American History* 83, no. 1 (June 1996): 44–69.

15 Two of the original sources for the video's soundtrack are available online: Interview with Alice Gaston, Gee's Bend, Alabama, 1941, Library of Congress, Archive of Folk Culture, American Folklife Center, https://memory.loc.gov/ammem/collections/voices/title.html. For the audio recording and transcript of Lyndon B. Johnson's June 23, 1964, call with Senator John Eastland of Mississippi, see the University of Virginia's Miller Center website: https://millercenter.org/the-presidency/secret-white-house-tapes/conversation-james-eastland-june-23-1964 (Tape WH6406.14, Citation #3836, Recordings of Telephone Conversations—White House Series, Recordings and Transcripts of Conversations and Meetings, Lyndon B. Johnson Library). *Exchange* specifically samples Senator Eastland's voice saying, "I think it's a publicity stunt." The artists relayed that they were influenced by historical accounts of couples drinking each other's blood as a way to circumvent laws against interracial marriage. Interview with the author, February 9, 2010, SITE Santa Fe, Santa Fe, NM. One such incident is discussed in Daniel J. Sharfstein, "Crossing the Color Line: Racial Migration and the One-Drop Rule, 1600–1860," *Minnesota Law Review* 91, no. 3 (2007): 592–656. Sharfstein discusses the letters of James Flint (1819–22) who reports witnessing a case in Jeffersonville, Indiana, in which a white woman drank the blood of an African American man whom she wished to marry.

16 Watt has used photographs as references in other works like *Catastrophe* (2006), which is based on the widely disseminated photos of torture victims from Abu Ghraib. See Rebecca J. Dobkins, *Marie Watt: Lodge* (Salem, OR: Hallie Ford Museum of Art at Willamette University, 2012), 56–57.

17 See Christopher Bracken, *The Potlatch Papers: A Colonial Case Study* (Chicago: University of Chicago Press, 1997), and Alan Carin's review of it in *Journal of Interdisciplinary History* 30, no. 2 (Autumn 1999): 357–60.

18 Margo Machida, *Unsettled Visions: Contemporary Asian American Artists and the Social Imaginary* (Durham, NC: Duke University Press, 2008), 134–48.

19 The history of internment was explored further in a film program that served as a companion to the exhibition and that featured two works by filmmaker Rea Tajiri: *History and Memory: For Akiko and Takeshige* (1991) and the documentary *Yuri Kochiyama: Passion for Justice* (1993) about the noted Japanese American activist. I curated this film series in collaboration with Michelle Puetz, The Block Museum's former Pick-Laudati Curator of Media Arts, and Justin Lintelman, Film Programmer. A gallery installation of *History and Memory* was included in the exhibition *Relocations and Revisions: The Japanese American Internment Reconsidered* at the Long Beach Museum of Art (May–July 1992), which also included Aono's *Deru Kugi Wa Utareru.* For an in-depth discussion of Tajiri's *History and Memory*, see A. Naomi Paik, "Residues of Rightlessness: Ghosts and Afterlife of Internment," in *Rightlessness: Testimony and Redress in U.S. Prison Camps since World War II* (Chapel Hill: The University of North Carolina Press, 2016), 66–83.

20 *Relics from Camp: An Artist's Installation by Kristine Yuki Aono and Members of the Japanese American Community* is on permanent view at the Japanese American National Museum in Los Angeles.

21 For a further discussion of the Treaty of New Echota, see Bethany Schneider, "Boudinot's Change: Boudinot, Emerson, and Ross on Cherokee Removal," *ELH* 75, no. 1 (Spring 2008): 151–77. For a general introduction to the history of treaties between the United States and Native American nations, see Suzan Shown Harjo, ed., *Nation to Nation: Treaties Between the United States and American Indian Nations* (Washington, DC: National Museum of the American Indian and Smithsonian Books, 2014).

22 The Removal Act of 1830 was a US policy that in theory gave the Cherokee, Choctaw, Chickasaw, Muscogee (Creek), and Seminole Nations the "choice" of leaving their territories in the Southeast in exchange for land west of the Mississippi River but in practice precipitated forced removals. See Alfred A. Cave, "Abuse of Power: Andrew Jackson and the Indian Removal Act of 1830," *Historian* 65, no. 6 (Winter 2003): 133–53.

23 From April 2016 through February 2017 members of the Standing Rock Sioux and their allies protested the building of an oil pipeline near their territory; the Women's March was a global protest that took place on January 21, 2017, one day after the inauguration of US President Donald Trump. It mobilized out of a belief that Trump expressed misogynistic views during the 2016 presidential campaign. See Anemona Hartocollis and Yamiche Alcindor, "Women's March Highlights as Huge Crowds Protest Trump: 'We're Not Going Away,'" *New York Times*, January 2017, https://www.nytimes.com/2017/01/21/us/womens-march.html.

24 Marie Watt, unpublished interview with the author, Susy Bielak, and Lauren Watkins, October 4, 2017. John N. Low, *Imprints: The Pokagon Band of Potawatomi Indians and the City of Chicago* (East Lansing: Michigan State University Press, 2016). A brief discussion of *Placeholder* is included in Kara Thompson, *Blanket* (New York: Bloomsbury Publishing, 2018).

25 For an account that retrospectively reflects on these protests and puts them into a longer historical context of American social movements, see Tomiko Brown-Nagi, "The Long Resistance," *Law and History Review* 36, no. 3 (August 2018): 441–70.

26 Block Museum of Art visitor comment card, week of February 21–27, 2017

27 Ibid.

28 Dario Robleto, "If You Remember, I'll Remember," in *Disembodied Portraits: Portrait Miniatures and Their Contemporary Relatives* (Cleveland: Cleveland Museum of Art, 2013).

Installation view, *If You Remember, I'll Remember*, The Block Museum of Art, 2017.

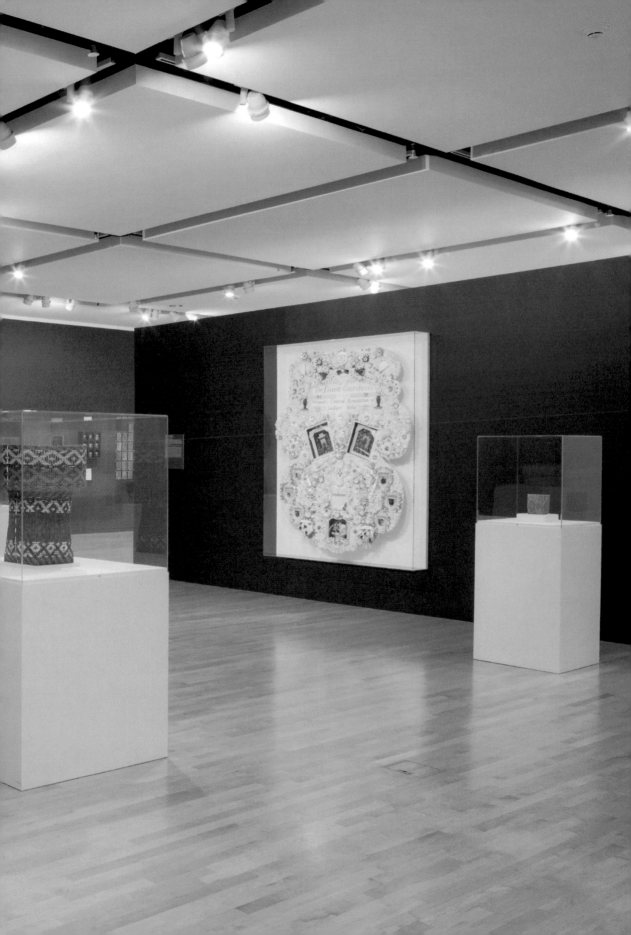

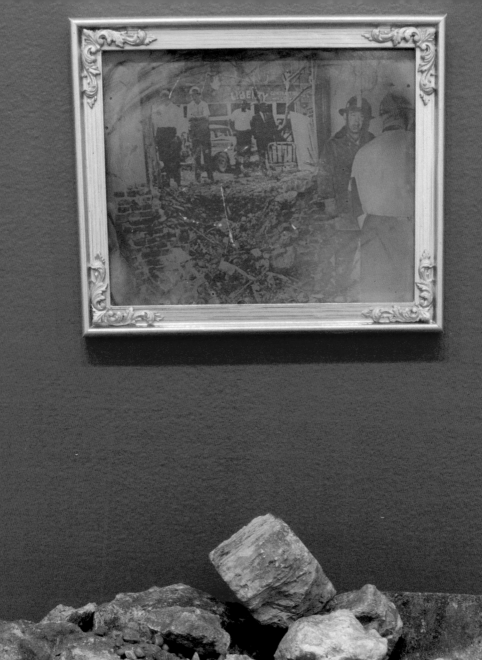

INTERVIEW
Joshua Chambers-Letson

The retrospective nature of this publication allows for the consideration of *If You Remember, I'll Remember*'s reception. In the following interview, Northwestern University associate professor of performance studies Joshua Chambers-Letson weighs in from his perspective as an educator who incorporated the exhibition into his undergraduate course, Introduction to Performance Studies, and as a scholar whose work places performance studies in conversation with a diverse set of fields including African American studies, Asian American studies, Latinx studies, Art History, legal studies, and Marxist theory. He reflects upon the exhibition as an opportunity for embodied learning, a form of institutional critique, and a site of respite.

SUSY BIELAK *What was your connection to and engagement with the exhibition? What attracted you and encouraged your involvement?*

JOSHUA CHAMBERS-LETSON I was drawn to the show because the curator, Janet Dees, organized it around questions that are central to what we explore in my department, Performance Studies. Something we ask a lot is how performance, embodied practices, and relational encounters with the aesthetic allow us to hold onto and transmit elided memories.[1] The field has contributed significant thought about the fundamental and performative role that elided histories of race and racism play in shaping contemporary life, accounting for histories of genocide and indigenous dispossession, war, colonization, apartheid, segregation, slavery, racial terror, internment, exploitation, and incarceration.[2] For Black, Brown, Asian, and Indigenous people this is the history of these United States, but within official narratives of the nation we often see these histories get dismissed, erased, reduced to footnotes, or revised beyond comprehension.

A central contention in performance studies is that performance can be a means of transmitting knowledge and values across time and space, between bodies, generations, or different cultural contexts.

Samantha Hill, *Herbarium: A historic reflection inspired by the Mason family collection* (detail), 2015–17. Installation view at The Block Museum of Art, 2017.

So in this way we could say that the show was performing the act named in the title: drawing people to engage in the collective practice of transmitting and remembering pasts that are under erasure— a practice that always carries with it the possibility of opening new horizons for the present or for the future. As art can have the power to offer a shift in perspective or make material, palpable, and present that which is obscured within plain sight, the works in *If You Remember, I'll Remember* brought these histories into view and gave us a stage to work through some of the implications of this fact. Not so much to resolve them but to have a chance to encounter and live within their unresolvability. And to experience this as a part of our condition of being together now in an unfolding present that is emerging always from these histories, whether we remember them officially or otherwise.

SB *Would you speak from the vantage point of a faculty member as to what you see the role of a project like this is?*

JCL I incorporated it into my undergraduate class, Introduction to Performance Studies. The vein of performance studies that I'm most invested in is not only interested in ontology or epistemology—what something is or how we know it—but also performativity. That is, what a thing or body does, how it acts, or what it makes happen. The exhibition was an ideal opportunity to talk about the way objects—in this case, the art object—*perform*. We drew on the work of political theorist Jane Bennett to talk about the vibrant materiality of objects as we considered how the objects on display in the gallery have their own performative powers in the way they make something happen when they interact with each other and the spectators.[3]

SB *You mentioned thinking about how things perform in the world. Would you give an example or two of this?*

JCL Performance studies doesn't just study the types of events that we often think of as performance—art or dance, for example, or even everyday practices like courtroom rituals or carrying out the operations of your job. There are a number of us who are also interested in the way that things, or objects, perform.

One example I can give is based on something very personal that happens in grief. Often, when we lose someone we had strong attachments to, we may come to find that their former possessions are imbued with a kind of power or lingering trace of them. A pair of earrings your late mother wore might become sacred to you— you wear the earrings, carry them on your person, or put them on a shrine to the deceased, quietly cherishing and protecting them.

It's as if such objects carry a part of our loved ones, bringing them back into the room in some sense. And if you lose the earrings, even or especially years after your mother transitioned out of life, you might mourn the object as if you'd lost her a second time over. So objects are always performing in the world, affecting and changing it, making things happen to and in it—in us. This is something artists—both object and body based—know better than most of us. I've heard curators describe museums as "mausoleums" dedicated to the collection and conservation of relics: dead objects that have been removed from circulation amongst the living. But curators arrange objects in a certain way to allow them to come to life and tell a story when a spectator interacts with them. That's what I mean by the way things perform.

SB *The way material objects can support and invoke mourning and reflection is certainly part of this exhibition.*

JCL The students really got into that concept. Interacting with the exhibition and Janet's visit to the class, in particular, helped us grasp some of the more difficult theoretical notions at hand. It was one thing to propose the idea that an encounter with an art object might compel you to feel, or move, or act in a certain way. Or to teach that performance is a means through which memory is transmitted. It's another thing to learn these ideas through embodied experience. The students were really taken with Kristine Aono's *The Nail That Sticks Up the Farthest...*, in which one is invited to take a nail representing a Japanese American person imprisoned by the US government on racist grounds during World War II and pin it onto a panel that features reproductions of letters from the artist's grandfather—a camp survivor. When we take that nail and push it into the piece, we not only make the piece but experience how an object can choreograph the body's movement. And we engage in the process of transferring and keeping alive the memory of Aono's grandfather.

SB *Were there other pieces or encounters that helped crystallize thoughts or theoretical concepts for you and for the students?*

JCL The piece that I was most affected by was Samantha Hill's *Herbarium*, a response to the 16th Street Baptist Church bombing in Birmingham, Alabama. The piece was stretched along a long wall and had a number of elements including photographs, text, and objects like string, dirt, and botanicals. A work like this asks a spectator to take time with its different fragments in order to produce meaning. It can mean giving your body over to the piece: you have to walk up and down the length of the wall, pausing to take in different elements

as you attempt to make sense of these fragments of a history that was literally blasted wide open and apart. *Herbarium* is a portrait of the beauty and power of Blackness and Black life in the United States, insofar as Black life grows from and lives in the most hostile of soil. *Herbarium* interacts with the spectator's body to make a fleshy portrait of Black life as it is lived after catastrophe, while also being, still, under threat and threatened with erasure or destruction. The piece invited the spectator to inhabit a corporeal practice of knowingly encountering and gathering the scraps that are left in the wake—to borrow language from Christina Sharpe—of that kind of living.[4] It gives us materials and space to engage the hard work of performing memorialization for Addie Mae Collins, Carol Denise McNair, Carole Robertson, and Cynthia Wesley, such that some trace of their lives could be conjured into the gallery to be mourned, remembered, and lived for. And as we bring them into the room through the encounter with Hill's work, we might also do the work of conjuring others that have been lost: Trayvon Martin, Rekia Boyd, or Sandra Bland. The experience of *Herbarium* suggests that kind of work requires a kind of constant motion, a moving up and down the length of the wreckage of history to gather the fragments you need to remember, and that you'll need carry forward with you on the journey into some kind of different future. This is what Sharpe describes as "wake work."

SB *Yes, Samantha Hill's and Kristine Aono's pieces seem to hold the exhibition. The two works flanked the two longest walls of the gallery and performed at a scale that's at once architectural and intimate. Each opens a well of meaning—of life and loss, of pain and endurance— through material form. In* Herbarium, *there are multiple tableaus with exquisite tintype portraits the scale of a palm and typewritten notes denoting specific acts of violence against those bodies. With* The Nail That Sticks Up the Farthest, *there are copies of letters handwritten by Kristine's grandfather referencing his experience of being incarcerated in the Japanese American internment camps, layered with pages from testimonies of former internees given during the 1981–83 Commission on Wartime Relocation and Internment of Civilians. These works can be read from a distance but are enriched by proximity, close looking, and, in the case of Kristine's work, touch.*

JCL After working with Janet, a lot of the students were interested in thinking about the performative power of curation for their final projects. Some thought about the theatricality of the curation, others engaged its activist dimension. Abstract concepts were made material and palpable by the end of our encounter with the exhibition.

SB *What you have shared is so illuminating in terms of how the exhibition served the class and expanded your students' perspectives. Would you speak to what you think a project like this can do more broadly on a campus?*

JCL In many ways the radicality of an intervention that comes from a place like Northwestern or The Block is always going to be tempered by its institutionality, its institutional history, and the institution's often-fragmented relationship to some of the communities the exhibition was in conversation with. To bring a show largely featuring the work of artists of color to The Block is an ambivalent affair since people of color are often excluded from, exploited by, or alienated within elite education and art institutions like The Block or Northwestern.

But, on a very personal level, as a person of color in a largely white institution, there was an element to the show's presence that felt like respite. It was nice for five or six months to have a place where I could walk a short distance from my classroom and go and sit with the work of artists who are thinking seriously about the questions of how we, as people of color, as people with various histories under erasure or various violent histories, are dealing with life in the wake of any range of ongoing catastrophes. And it offered a little refuge from the everyday forms of racism that can structure life on the university campus.

Art is imbued with an extraordinary revolutionary capacity, but this power is often very minimal, even microscopic in its impact. A piece might only affect a person or two and in small or subtle ways. The encounter with a piece might, as I just said, be the offer of respite or affirmation when you need a space to keep on keepin' on. Or it might help someone remember something they didn't know they'd forgotten, or it might change and rearrange their perspective, perception, or consciousness. I draw a lot on the tradition of thinkers like Nina Simone, Herbert Marcuse, Louis Althusser, José Muñoz, Adrian Piper, or Lisa Lowe, who insist that art may not change the world but can galvanize, transform, and change people who can in turn transform the world.[5] An exhibition like this can forward or keep alive a kind of spirit of inquiry, exploration, and critique that allows for other, more insurgent capacities to become common, right? Little things with the potential to spark revolutionary transformation…

SB *It's not the same as direct action, but that's okay…*

JCL Yeah, or maybe it's not okay, but I don't know how we change that overnight, and I don't know how one exhibition transforms that.

SB *I think that reflection and action can be simultaneous; the possibility for transformation takes different shapes.*

JCL I think that's always the case with the aesthetic. It's not that it's going to lead to an insurgency, but it can spark that potential that, in turn, might lead to a catalytic transformation in the spectator and in the institution that coheres in insurgency.

It might be that somebody goes to the show and ten years later, while mounting some kind of transformative campaign, draws on some of the work they saw. They might not even remember that they saw it. That's part of the power and danger of aesthetics: we can't exactly trace or measure how they're powerful or when and how they'll affect us.

SB *As a teacher, then, what is your perspective on the ways that we might take up this work responsibly? That is a question that we're asking ourselves with the understanding that mounting work and opening the door is not necessarily the end.*

JCL I struggle a lot with that question. Can we do this responsibly from within an institution like the university or museum? I have been thinking about how privileged, elite institutions like Northwestern or The Block are constantly asking: "How do we serve the world outside the university?" It's a dissonant thing when an institution that defines itself through its elite and exclusive status waxes poetic about its commitment to public service or social justice. Especially when the institution's elite status is secured with huge sums of capital, with all the forms of abuse, theft, and exploitation such reserves of money imply. Even more so when the institution is built on a history of excluding and devaluing the presence and work of people of color, women, and members of the working class.

For this reason, I think it is helpful to think along the lines of Fred Moten and Stefano Harney who suggest that instead of constantly defending the university's status as a site of knowledge production or our place within it, we might smuggle knowledge out of it.[6] Both the museum and the university have historically been central apparatuses in the reproduction of class, race, and gender-based hierarchy in the United States. So if we follow Moten and Harney alongside a Rosa Luxemburg or Felix Gonzalez-Torres, we might take a parasitical or even piratical relationship to institutions like Northwestern or The Block, stealing and redistributing the knowledge and resources that the institution hoards, while working within its internal contradictions in service of the still radical goal of making life more livable for everyone.[7] The show seemed to be doing that work pretty explicitly.

It's inspirational to see that happen. It doesn't happen enough. Many of us who came to work within institutions like this fostered some hope of fomenting social change but find ourselves in the uncomfortable position of trying to transform something that in the final instance is more likely to transform us. We come to transform the institution and find ourselves working in the service of it. A lot of the time we realize that the university or the museum was never going to make the kinds of viable changes in the world that we want or need. They may actually be significant forces standing in the way. That's part of the paradox of having a life in relationship to a major institution. If not just a kind of ethical taint.

SB *Yeah, compounded by the moment that we're living in politically.*

JCL Truly. But sometimes we can create spaces *within* institutional spaces where the potential for a catalytic or transformative encounter might happen. If we feel trapped in the present political moment, one of the things the encounter with the aesthetic can do is give us a glimpse or glimmer of other possible moments. Remembering other possibilities for what *could have* happened in the past and creating a space where we might come together and create new and better options for the present and future.

SB *Agreed. Speaking to encounters, this exhibition puts a range of histories—of violence, of relocation, internment, resistance, civil rights— into conversation. The specific situations and conditions each artist is referencing, from the forced relocation of Native Americans to the prohibition of interracial marriage, are rarely considered in relationship to each other. One common thread is that they all occurred in nineteenth- and twentieth-century North America.*

JCL W.E.B. Du Bois used to speak of the "dark proletariat" when referring to racialized workers from Africa, Asia, Oceania, and the Americas whose fates and histories had been woven together by the European colonization of the world and the attendant development of modern global capital.[8] Working from Du Bois, Lisa Lowe also describes the "intimacies of four continents" as tying together different spatial, national, temporal, and cultural contexts and histories. It's imperative to historicize the differences and offer an account, for example, of the way Indigenous dispossession and genocide is different from histories of the enslavement, natal alienation, and dispossession of the Black body. But it's also imperative to think about how these processes have occurred in relationship to each other.

One of the things that the show allowed us to see is that, while Marie Watt and Samantha Hill gesture to radically different histories, the ongoing legacies of those continued histories share something and overlap. The show made it very, very clear that the political horror that we are living through right now, which seems spectacular and new, is actually the baseline, ambient state of politics in the United States. There has never been a time in this country's history when Black, Brown, Asian, and Indigenous people weren't being incarcerated, terrorized, murdered, dispossessed, or destroyed by the US government or its population. For example, in a general sense we could say that concentration camps—meaning camps in which large numbers of people are concentrated by the state on grounds such as ethnicity, national status, or political affiliation—aren't anathema to US values. Rather, they are a tried-and-true tactic in the arsenal of US governance from ICE detention centers to the military's use of Guantanamo Bay to house terror subjects and, earlier, Haitian refugees, to the incarceration of Japanese Americans during World War II, to the reservation system, to the plantation. What would it mean not to flatten these differences into what they share but to recognize that they have some relationship to each other? And to the histories under erasure that the show confronts us with.

And maybe that goes back to the question of what an institution can do, or more nearly what people can do within the institution. What Janet did with this show was mobilize the institution's resources to hold up a kind of mirror and say, "This is what this country is. This is who we/you are." Our present crisis didn't emerge with the 2016 election. After all, the show had been planned in advance of it. Trump didn't invent the racist, white supremacist presidency. This is what this country was before Trump, before it was even a country. A show like this refuses to forget that fact and asks us the perennial question, What is to be done?

SB *So what does it mean for a project to surface some of these histories, to draw relationships between deep history, recent history, and our current moment?*

JCL It means we have to negotiate life with the knowledges the show presents us with: the profound, deeply contradictory ambivalent knowing that racism, for example, isn't an outlier of US ideology or the ideals of the US state. Rather, racism and white supremacy are central components in the engine of US history.

The inviting beauty of so much of the work in the show asked us to live in relationship to the ambivalence and sadness of such a truth without suppressing or forgetting it. What does it mean to live, always, in the wreckage or in the wake and to not have a way out? And what if

one of the effects of living in the wreckage means that the wreckage becomes your materials for building something new? Perhaps a work of art or even a different world. This is something that radical artists of color, like the artists in the show, have long shown to be possible.

One can work with the wreckage to produce extraordinary things. The Samantha Hill piece is an example of an artist using the wreckage of the 16th Street Baptist Church to make something new. The Black radical tradition has often been about working with life's wreckage to produce more life. Artists like Hill, or Nina Simone, Spike Lee, and Toni Morrison, have mined the wreckage of that church not to give us a path out but a path through. A path out means we have to leave the wreckage behind. I don't want to forget the four children who died in that church. Hill (and Dees, by extension) won't let us. The work thus asks us if we can learn how to live responsibly within the wreckage. And then, perhaps, if we can create conditions in which such catastrophes might not have to happen, or happen again, or happen anew. Indeed, the performance of memory that the show invites us to embody and experience might be the subtle seed of transformative new worlds that are not yet imaginable but in every way possible.

NOTES

1 See: Joseph R. Roach, *Cities of the Dead: Circum-Atlantic Performance* (NY: Columbia University Press, 1996); Diana Taylor, *The Archive and the Repertoire: Performing Cultural Memory in the Americas* (Durham, NC: Duke University Press, 2003).

2 Karen Shimakawa, *National Abjection: The Asian American Body Onstage* (Durham, NC: Duke University Press, 2002); José Esteban Muñoz, *Disidentifications: Queers of Color and the Performance of Politics* (Minneapolis, MN: University of Minnesota Press, 1999).

3 Jane Bennett, *Vibrant Matter: A Political Ecology of Things* (Durham, NC: Duke University Press, 2010).

4 Christina Sharpe, *In the Wake: On Blackness and Being* (Durham, NC: Duke University Press, 2016).

5 Herbert Marcuse, *The Aesthetic Dimension: Toward a Critique of Marxist Aesthetics* (Boston, MA: Beacon Press, 1978); Louis Althusser, "The 'Piccolo Teatro': Bertolazzi and Brecht," in *For Marx* (1965) (London/NY: Verso, 1999); Adrian Piper, "Talking to Myself: The Ongoing Autobiography of an Art Object," in *Out of Order, Out of Sight,*

vol. 1, *Selected Writings in Meta-Art 1968–1992* (Cambridge, MA/London: MIT Press, 1996); Lisa Lowe, *Immigrant Acts: On Asian American Cultural Politics* (Durham, NC: Duke University Press, 1996); José Esteban Muñoz, *Cruising Utopia: The Then and There of Queer Futurity* (New York: NYU Press, 2009).

6 Fred Moten and Stefano Harney, "The University and the Undercommons: Seven Theses," *Social Text* 79, no. 2 (2004); *The Undercommons: Fugitive Planning & Black Study* (Brooklyn, NY: Autonomedia, 2013).

7 Rosa Luxemburg, "Social Reform or Revolution," in *The Rosa Luxemburg Reader* (1899), ed. Peter Hudis and Kevin B. Anderson (New York: Monthly Review Books, 2004); Felix Gonzalez-Torres, "Interview by Tim Rollins," in *Felix Gonzalez-Torres*, ed. Felix Gonzalez-Torres, et al. (New York: A.R.T. Press, 1993).

8 W.E.B. Du Bois, *Black Reconstruction in America 1860–1880* (New York and Toronto: The Free Press, 1998).

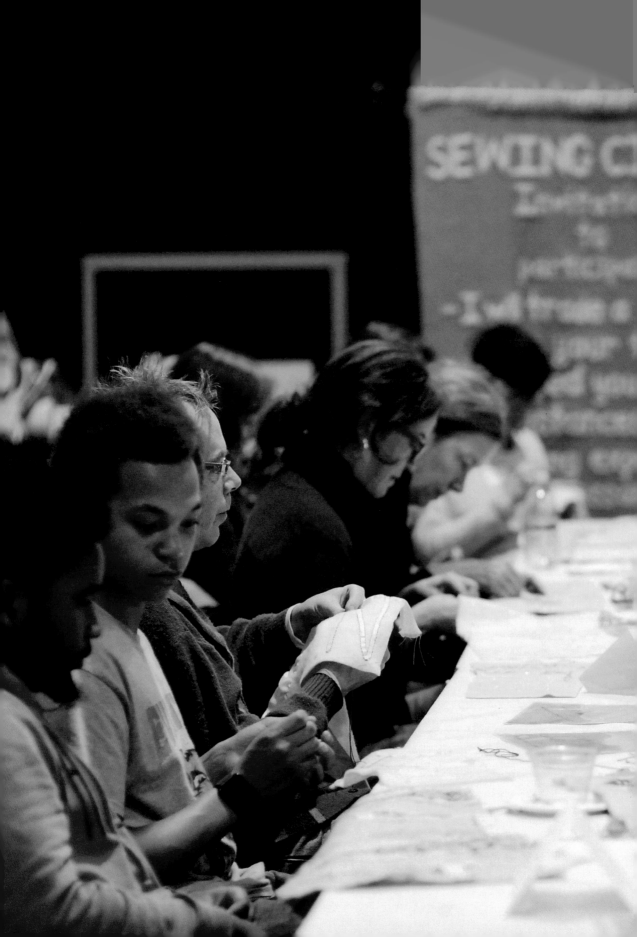

IMPRINT OF EXCHANGE: ENGAGEMENT AND PUBLIC PRACTICE IN IF YOU REMEMBER, I'LL REMEMBER

Susy Bielak and Lauren Watkins

When I showed Deru Kugi Wa Utareru [The Nail That Sticks Up the Farthest Takes the Most Pounding] *at the Long Beach Museum, it was installed in 1992 when the Rodney King verdict came out, and riots were happening in the streets. When that piece was shown, I was thinking people would just add nails to the wall like they were asked to, but people used it as a form for expressing their sense of injustice with what was happening right then. So that's when the words "No Justice, No Peace," "Never Again," and "Racism Still Exists" appeared. That was, for me, a pivotal point of thinking, "This is bigger. This is not just about the Japanese American experience... This story about the Japanese American internment is bigger than just history. It's about this ongoing struggle for equality and justice."*—Kristine Aono[1]

The artists in *If You Remember, I'll Remember* actively brought history into conversation with the present around fundamental questions of social justice and human rights. Just as Kristine Aono's work *Deru Kugi Wa Utareru* offered a site of connection when it was originally presented in 1992, we were invested in creating similar opportunities with *If You Remember, I'll Remember* twenty-five years later. The Block's cross-departmental team envisioned and developed the exhibition and engagement programs for *If You Remember* holistically. In the process, the team developed an arc of engagement that invited community members and Northwestern University faculty, students, and staff together through reflection, dialogue, and participation.

1 Community members at the Equity Sewing Circle with Marie Watt, organized by The Block Museum of Art, February 8, 2017.

This process resulted in programs and activities before, during, and after the exhibition's presentation (documented in the Appendix on page 121). This essay focuses on the extensive projects developed with artists Kristine Aono and Marie Watt for *If You Remember.* In doing so, it offers a case study for the ways in which extended relational work and co-created content can develop deep investment by multiple audiences in the museum's work and contribute to a project's impact.

This type of socially-engaged work is increasingly an integral part of museum practice and an important part of the art experience of museum visitors at The Block and in the larger field.[2] As Sarah Schultz describes, socially-engaged practice resists "the notion that the museum is the primary author of content and experiences" and blends "social, intellectual, and creative experiences and encounters."[3] In her influential book *The Participatory Museum* (2010), Nina Simon described cultural institutions as striving to be "relevant, multi-vocal, dynamic, responsive community spaces."[4] She proposed that "inviting people to actively engage as cultural participants, not passive consumers" would be a path for cultural institutions to "reconnect with the public and demonstrate their value and relevance in contemporary life."[5]

Because of the ephemerality of process-driven and participatory work—and how it falls outside of the traditional modes of museum documentation—it is often invisible. This essay is our contribution, in dialogue with others in the museum field, to models of making this activity transparent. The interviews that follow this essay offer the

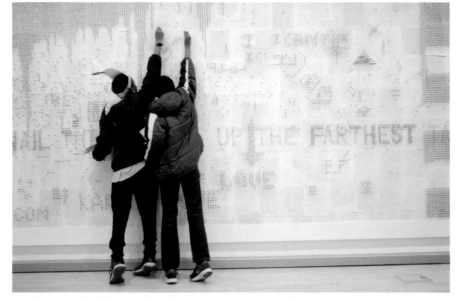

2 Members of Y.O.U. contributed to Kristine Aono's installation *The Nail That Sticks Up the Farthest...* during a family night program in spring 2017.

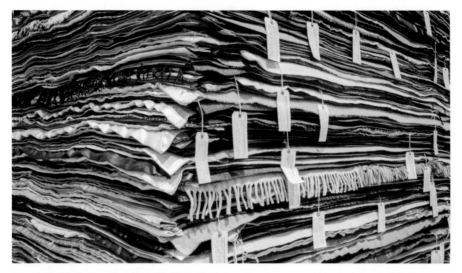

3 Marie Watt, *Dwelling* (detail), 2006. Reclaimed and new wool blankets, satin binding, manila tags, and safety pins. The Aldrich Contemporary Art Museum, Ridgefield, CT.

reflections and critical assessments of four of the many people who contributed to and participated in Aono's and Watt's projects.

ENLISTING ARTISTS AS PARTNERS

The curatorial and engagement departments worked together with Kristine Aono and Marie Watt to develop a suite of related engagements to take place before and during the run of the exhibition, built out of conversations with campus and community partners [FIGS 1, 2]. This process unfolded over a year, through site visits and numerous virtual and in-person conversations. Both artists created significant participatory artworks for the exhibition and worked with our cross-departmental team to develop and take part in an arc of activities on and off campus.[6]

Aono and Watt were ideal artists to engage in this way. They both integrate process and participation in their work by actively inviting the hands, thoughts, materials, and lived experiences of others. For instance, for her prior installation *Relics from Camp* (1996), Aono worked with different Japanese American communities to collect and incorporate objects that internees and their families had saved from the camps.[7] Watt similarly solicits objects and stories from communities; her ongoing sculptural series entitled *Blanket Stories* is comprised of artworks made from blankets and related narratives that people share with her [FIG 3]. Aono and Watt also share an interest in and experience with working with people across difference, which we knew would be critical given the range of individuals we hoped to engage.

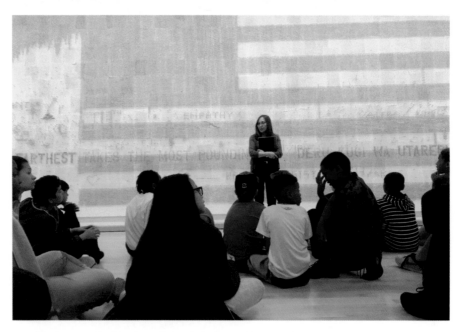

4 Kristine Aono facilitating a field trip in front of *The Nail That Sticks Up the Farthest...*

Both Aono and Watt have experience as educators and relayed that teaching fuels their creative practice [FIG 4]. Aono summarized her path towards working in an engaged way: "I've worked with so many museums and organizations where I'd have an exhibit, and they just added on and [asked], 'Can you do a workshop?' And then I would, but it just didn't seem to be integral to what the exhibition was. And I thought, 'I have no training in teaching.' And so, I took some training workshops and got more involved in [teaching] and realized that it could be a real facet of what I do in a larger sense. So, I feel like I am a teacher now; I work with communities."

OUTREACH/RESEARCH: SEEKING STAKEHOLDERS

The Block's work is centered on our many communities. As an institution situated within a major research university and committed to being free and open to all, we conceptualize the constituencies of The Block as rings of a tree—starting with the campus, then Evanston and Chicago—and develop our work bearing stakeholders from each of these contexts in mind. We organize programs designed to further scholarship and curricula on campus; host gatherings designed by and for students; produce programs exploring experimental pedagogy and artistic practice; and foster deep, community-sited, grassroots projects. Across all of this, our work is grounded in a process-driven practice that emphasizes dialogue and partnership with the communities we are hoping to engage [FIG 5].

The university context provides academic freedom and investment in innovation, allowing university museums, like The Block, to

support the time-intensive and evolving nature of relationship-driven work and to "be more daring, host unconventional activity and innovative pedagogies."[8] Its rich interdisciplinary context readily provides resources for the university museum to "leverage skills and experiences from different fields to create and manifest new knowledge."[9] A belief in serving as civic spaces also means many university museums are invested in engaging "the public and decision-makers together in acts of problem-solving and crafting vision."[10]

Given the complexity of our context we start with person-to-person connections and build from there. Outreach conversations function as an active form of research. Working in this way, we are able to foster more symbiotic relationships and exchanges. Content is enriched by the insights, ideas, and new relationships that we might not have identified otherwise. Our process is rhizomatic, working with an intentional open-endedness towards the forging of networks that ultimately yield productive partnerships to co-develop work.[11] Pedagogically, this mode of working relates to a belief and investment in mutual learning and in the "community as the curriculum."[12]

As we initiated our collaborations with Aono and Watt, we simultaneously began conversations with potential local stakeholders to test the conceptual framework and relevance of the artists' work. Beginning on campus, we approached faculty and students across disciplines (e.g., Asian American Studies, English, Performance

5　Participants in The Block's 2014 Artists' Congress: Nicole Gurneau, Daniel Tucker, Michael Rakowitz, Anthony Romero, and Susy Bielak (right to left) introducing a collectively-written Call to Artists. The program was inspired by the first American Artists' Congress in 1936 and organized by Bielak, Rakowitz, and Tucker.

Studies, Political Science) whose scholarly work on topics such as war, trauma, remembrance, and public memory resonated with the exhibition. Colleagues at Multicultural Student Affairs, Social Justice Education, and the Center for Civic Engagement whose work relates to social justice, inclusion, and diversity were important interlocutors. In each conversation, we asked for additional contacts with whom we should speak, which in many cases jump-started new relationships.

Aono and Watt participated in separate intensive, immersive site visits in which they met with leaders from local nonprofits and community organizers as well as students, faculty, and university administration—contacts developed from our earlier outreach phase (see full site visit itineraries in the Appendix on page 121). For example, meetings included one-on-one conversations with university leadership, such as the Associate Provost and Chief Diversity Officer, the Director of Social Justice Education, and Director of Neighborhood and Community Relations. We met with colleagues at the Evanston-based Youth & Opportunity United (Y.O.U.) as an extension of our ongoing partnership as well as new contacts at organizations such as the American Indian Center and Japanese American Service Committee, both based in Chicago. We hosted coffee sessions open to undergraduate and graduate students, faculty, staff, and community leaders who were curious about the themes of *If You Remember* more broadly or Aono's and Watt's work in particular [FIG 6].

Each meeting began with the artists giving an introduction to their work, speaking both about ongoing concerns in their artistic

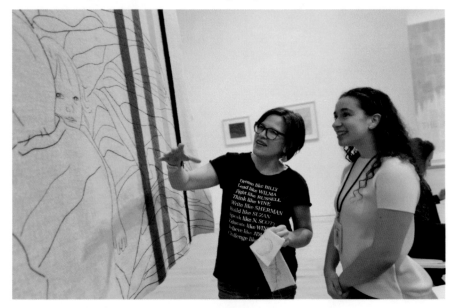

6 Marie Watt (left) speaking with a Northwestern student about *Witness* during the opening day program of *If You Remember* on February 4, 2017. In each of her visits to campus, Watt actively engaged students, part of her ongoing commitment to pedagogy.

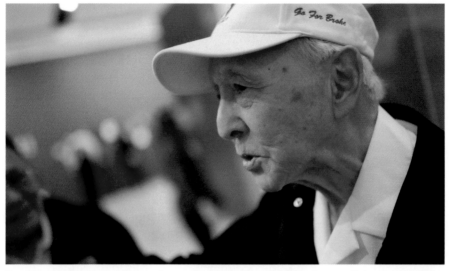

7 James Mita shares his experiences during the Day of Remembrance, February 18, 2017.

practice and their work vis-à-vis *If You Remember*. Then we would ask our guests: What resonates with your concerns? What kinds of experiences would be meaningful and interesting to you? This approach resulted in productive conversations covering expansive terrain.[13]

For example, in conversations with Aono and colleagues from Y.O.U., we discussed the problem of silencing and erasure in history, including in public education. With leaders from Northwestern student groups such as the Asian Pacific American Coalition, the Immigrant Justice Project, and Sustained Dialogue, we discussed the place of personal experience in public work, trauma and fear, action and non-action, "aliens" and inalienable rights.[14]

During Watt's site visit, topics ranged from Indigenous forms of scientific knowledge to proto-feminism. We talked about the materiality of memory and the archive as well as the politics of water and Northwestern's and Chicago's place on the shores of Lake Michigan. We also mined issues of concern on campus—including recent efforts to acknowledge and reflect on complex histories of Northwestern's relationship with Native American and Indigenous communities and ongoing efforts to re-map and re-indigenize spaces through oral history projects and native plant gardens.[15]

As noted in Dees's essay in this volume, the divisive 2016 presidential election formed the backdrop for both artists' initial site visits. Watt's visit coincided with Election Day. The following day when we met again, the results of the election had been announced. During our meetings, we were all aware of what was happening outside of the museum's walls. This amplified the gravity and relevance of *If You Remember* and the interest in actively considering resonances between the past and present. Allyship, solidarity,

and intergenerational exchange were also themes that emerged in discussions with community nonprofits and student groups alike. Overall, there was a sense that Aono and Watt's work—and our project as a whole—could catalyze and offer forums for people to come together at a time that felt marked by an urgent need for dialogue and connection [FIG 7].

TURNING IDEAS INTO EXPERIENCE

Following the site visits, we worked quickly to synthesize the many emergent ideas and give shape to potential programs and points of connection. There were too many ideas to realize. Through several rounds of discussions with Aono, Watt, and campus and community participants, we gauged their interest and willingness to work toward manifesting some of these ideas. We prioritized based on shared interests, a desire for a balance and range of activity, and the capacity of the artists, collaborators, and ourselves. Ultimately, a variety of projects, programs, and activities took place over a six-month period, ranging in scale and scope and realized with different partners and participants.

Two major projects emerged as focal points: equity sewing circles centered around Marie Watt's work and a Day of Remembrance honoring Japanese Americans who were interned during World War II in alignment with Kristine Aono's work. As described in the preceding essay, sewing circles—and the interpersonal exchange they

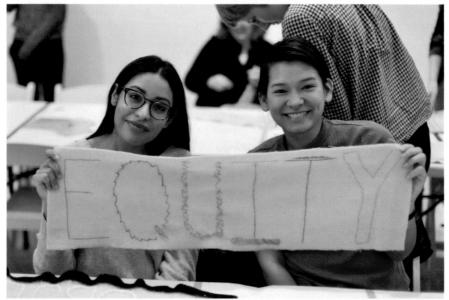

8 Two participants at the *If You Remember* opening day sewing circle on February 4, 2017, after stitching a text block on the theme of equity. Equity was the topic of a second sewing circle, which was held on February 8.

organically foster—have been an integral part of Marie Watt's artistic practice. They, in turn, became the key focus for her engagement vis-à-vis *If You Remember*. During her site visit, we learned that equity was a common theme of interest both on campus and in Evanston. While Watt's sewing circles are typically not organized around topics, there was consensus that an intentional focus on equity could be valuable. Working with Watt and a planning team of Northwestern staff, faculty, and students, we identified words that had personal associations with the notion of equity (e.g., "voice," "home," "native," "catalyst," "accomplice," "shelter," "solidarity") [FIG 8]. These became the building blocks for a sewing circle that transpired just a few days after the exhibition opening in February 2017. Over two hundred people from Northwestern, Evanston, and beyond came to embroider

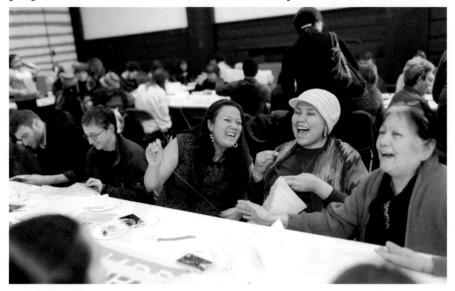

9 Community members mid-stitch during The Block Museum's Equity Sewing Circle with Marie Watt on February 8, 2017.

text blocks that Watt would turn into a new work for the exhibition [FIG 9]. At each table, facilitators, drawn from our campus partners, hosted conversations about equity. As described earlier in this volume, Watt took the stitches and panels that our communities contributed back to her Oregon studio, and they became the building blocks for new work. When she returned to install the piece, *Companion Species: Ferocious Mother and Canis Familiaris*, we invited the sewing circle participants to join us for an unveiling. As Watt expressed, "Each one of those text blocks feels like someone's unique signature or an extension of one's body, and that is something new in my work. That fact that it is so visible, I think, will shape future collaboration."[16]

Shortly after the sewing circles, we hosted another conversation-driven program, this one springing from Aono's work and in

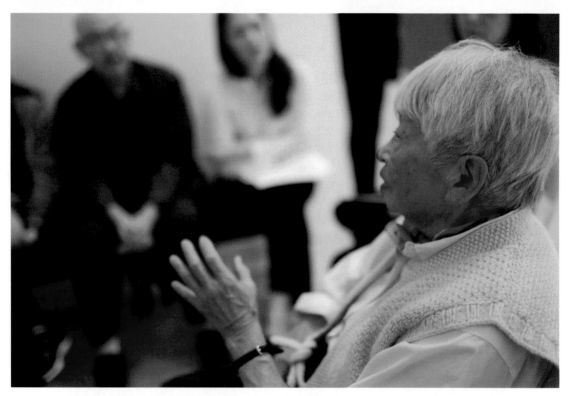

10 Merry Oya sharing her experiences during the Day of Remembrance, February 18, 2017.

recognition of the 75th anniversary of Executive Order 9066, which called for the internment of over 120,000 Japanese Americans living on the West Coast. Each year, Chicago-based Japanese American organizations including the Japanese American Service Committee, Chicago Japanese American Historical Society, Japanese American Citizens League, Japanese Mutual Aid Society, and Chicago Japanese American Council come together to organize a Day of Remembrance at the Chicago History Museum, honoring survivors and holding a light to this a difficult chapter of US history. Our colleague Anna Takada, a graduate fellow in Multicultural Student Affairs and an active member of the Japanese American community in Chicago, had the vision to amplify this occasion through Aono's work. She took this proposition to the Chicago Day of Remembrance planning committee and with great care secured their support in co-hosting an event at The Block as a complement to the one in Chicago. She worked with the head of the Chicago Japanese Historical Society to enlist six first-generation Nisei to share their experiences of being interned [FIG 10].[17] Their presence and willingness to share became the focal point for the event. For some, this marked the first time they would speak publicly about their experience. We paired each speaker with two moderators, entrusted to help hold the space with and for the speakers, as well as the participants. We drew upon Sansei volunteers whom Takada knew through partner organizations, as well as leaders from campus student organizations including the Japanese American

Student Association, Asian Pacific American Coalition, and Sustained Dialogue. While we had imagined an intimate event, more than two hundred people attended, filling our modestly-sized building with speakers and participants alike sharing their memories and stories across generations [FIG 11].

In addition to these large-scale events, there was a range of other public programs as well as many other points of contact for Aono and Watt. Both artists visited Northwestern classes, connected informally with students on campus, and met with youth in Evanston.[18] In the days leading up to the Equity Sewing Circle, Watt had lunch with students from the Native American and Indigenous Student Alliance. Their conversation resulted in the development of additional language around equity that guided the event. When Watt returned later that spring, she facilitated a sewing circle with local middle schoolers. In the spring, Aono met with students in Evanston Township High School's Asian American Heritage Alliance and then, at the invitation of the Japanese American Student Alliance, returned to campus to lead a writing workshop about objects that carry memory.

Still more activities happened without Aono or Watt present. We worked with the Poetry Foundation to host a public workshop reframing individual experience through historical texts and materials.[19] We returned to our new colleagues in Social Justice Education, whom we had met in the fall during Aono's visit, and asked them to facilitate a Block student docent training to bolster students' capacity to lead dialogue around complex personal and political topics that might surface during guided tours of the exhibition.

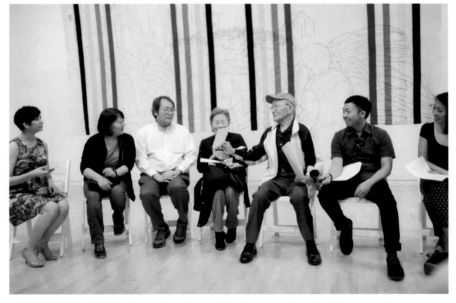

11 Enoch Kanaya, a veteran and survivor of the Japanese American internment camps, sharing his experiences during the Day of Remembrance, February 18, 2017.

Each event or activity affiliated with *If You Remember* happened through partnership. In some cases, key individuals outside of The Block took on lasting roles as collaborators and allies to the project as a whole. For instance, Ninah Divine, then the Coordinator of Northwestern's Native American and Indigenous Peoples steering group, played a key role in shaping experiences in relationship to Watt's work, especially the sewing circle described above, and making connections to people on and off campus invested in Native issues. As indicated above, Anna Takada was our primary partner for the Day of Remembrance, and beyond that event, *If You Remember* became a core focus of her work at Northwestern [FIG 12]. Takada advised on activities with Aono and continued to forge connections to community partners and students at Northwestern.[20]

As much as possible, we sought opportunities to maintain continuity with partners and participants so that connections didn't end following a specific event. For instance, an event was held to

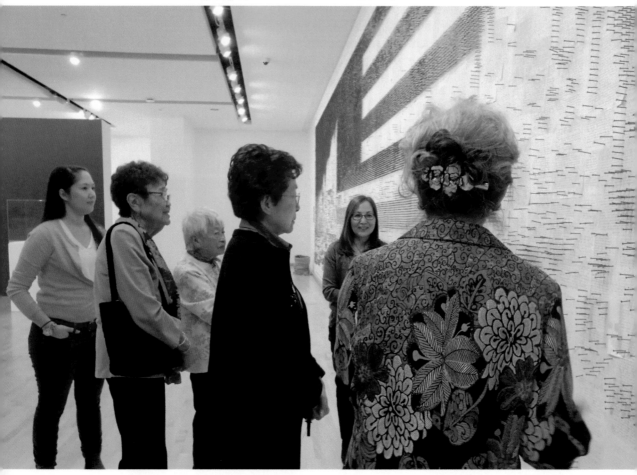

12 Sansei and Nisei speakers from the Day of Remembrance, with Kristine Aono and Lisa Doi, gathered for a partner dinner in spring 2017.

celebrate the unveiling of Watt's new piece, and all of the sewing circle participants were invited. We gathered the sewing circle organizers for lunch and a debriefing and held a dinner with Aono and the Day of Remembrance speakers and moderators [FIG 12]. Our partners in Multicultural Student Affairs approached us to plan a professional development session in our galleries for their entire team, recognizing that the exhibition and conversations we had together could inform their collective work in the future.

These are just a few snapshots of the extensive suite of public programs and informal gatherings and meetings that we organized; a comprehensive listing of activities appears on page 121. All of these experiences—including the large-scale events, intimate workshops, shared meals, and planning meetings—taken together, with the exhibition itself, constituted the project *If You Remember, I'll Remember.*

RIPPLE EFFECTS: REFLECTIONS AND CONSIDERATIONS

I don't separate a sewing circle and the community exchange, or even the imprint of that exchange on the people that were sewing. The sewing circles take a lot of time to prepare, and then on the other side of them, there's a lot of literally loose ends, and things that need to be stitched and sewed. It all has to come back together. If I was looking to speed my process up, I wouldn't recommend sewing circles. But what's so great about them, even within a two- or three-hour period, there's the potential for really deep exchanges. I feel lucky that this is part of my practice, because while I have stopped teaching—which I did for almost a decade—I now get to experience one of the best parts of that job, which is constantly learning from other people and growing as well.—Marie Watt[21]

In our post-facto interviews with Aono and Watt, they reflected on how valuable the time and energy we devoted to the process was to them. They shared that the opportunity for multiple touch points and site visits over the course of project was rare. Aono, who has family in the Chicago area, continues to be in touch with Block staff and others she met through this process. Watt, who didn't have a prior connection to Evanston and Chicago, says she now has "a kind of a connection with the community, and this is different than what's happened in the past ... it's a place where I feel like there's more work to be done and more relationships I want to continue to nurture."[22]

With *If You Remember*, we recognized an opportunity to collaboratively interpret history and current events with a wide range of constituencies.[23] Our primary measurement for the success of this approach to engagement was the resonance of experiences and quality

13 Marie Watt with attendees of the *If You Remember* opening day program sewing circle, including Melissa Blount (second from right). Blount went on to host sewing circles in Evanston to create a Black Lives Matter Witness Quilt.

of connections. For The Block, *If You Remember* was catalytic in deepening relationships on campus and in the community, in expected and unexpected ways. Campus partnerships with units including Multicultural Student Affairs, Native American and Indigenous Studies, and Social Justice Education have been strengthened and a number of students who attended site visit meetings or public programs applied to work at The Block as student docents. We developed an ongoing partnership with the Chicago-based Poetry Foundation, which has since regularly hosted writing workshops in relation to our exhibitions.

We learned by circling back to partners and participants that the events sparked connections not only with The Block and its staff but also between community members. For example, a group of prior strangers exchanged contact information after spending the morning together at our first sewing circle [FIG 13]. Nearly all of them came back to the second sewing circle. While we only had the capacity to organize two sewing circles, community members were inspired to initiate their own. A member of this impromptu group, Melissa Blount,

was inspired to launch her own sewing circles to create a Black Lives Matter Witness Quilt.

For all of the positive outcomes and relationships, there were challenges. While we carefully considered the amount of time, labor, and interaction we would ask of each artist, Aono and Watt relayed that, though exciting, at times the work we did together was intense and overwhelming.[24] They also acknowledged the temperament necessary for this kind of work. Watt shared, "I think that one thing in the collaborations that's really important [is being] committed to a process but also [having] this willingness to be malleable and go with the flow."[25]

A malleable process can be messy. There is the potential for hiccups and failures, distance between intent and impact, and power differentials in partnership. For instance, while the shared commitment to adaptability was productive in shaping engagement activities, there were more ideas than we were able to realize. And, while inevitable, when you solicit others' ideas and aren't able to actualize them, it can feel like—and be perceived as—a failing. When possible, we shifted to find alternative solutions. For instance, student group leaders were inspired in meeting with Aono to organize a teach-in. While this wasn't manifested, students participated as program facilitators, fostered independent relationships with the artists, and hosted independent gatherings in the exhibition itself.[26] The partner and participant interviews that follow, while largely positive, point to other issues that emerged during *If You*

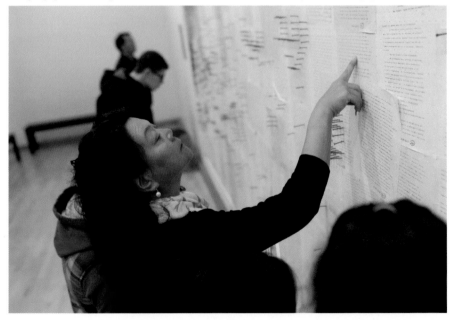

14 A community member reading letters from Kristine Aono's grandfather, part of *The Nail That Sticks Up the Farthest...*, during the Day of Remembrance, February 18, 2017.

Remember— including missed opportunities, the complexity of a largely white staff leading projects related to race, relying on minority colleagues to represent the museum in community partnerships, and fundamental questions of how institutions can support social justice.

Marie Watt's sewing circle description that opened this section— from which this essay also takes its title—is an apt metaphor for the relational and process-driven work of engagement and public practice. This work requires investment—in listening, building and sustaining relationships, fostering trust, developing ideas, negotiating collaboration, and creating the time and space for reflection [FIG 14]. In the words of Randall Szott, "All art is socially engaged ... so *how* an artwork, or art person, is socially engaged becomes the actual question rather than *if* it is."[27] This reflection serves as a guide not only for *what kind* of engagement we develop at the museum, but *how* we develop it and with *whom,* as well as for the ever-important role of inviting other perspectives on how well we are doing the work.

NOTES

1 Kristine Aono, unpublished interview with the authors and Janet Dees, October 4, 2017.

2 There is ongoing debate, definition, and redefinition of the terms *engagement*, *social practice*, and *public practice*. Tom Finkelpearl's definition of *social practice*, "where the social interaction is at some level the art," applies to our work, which also integrates Suzanne Lacy's definition of *new genre public art*, "being activist, often created outside the institutional structure which brought the artist into direct engagement with the audience, while addressing social and political issues." As indexed by Claire Bishop, these modes of working have also been referred to as "socially engaged art, community-based art, experimental communities, dialogic art, littoral art, participatory, interventionist, research-based, or collaborative art." Tom Finkelpearl, *What We Made: Conversations on Art and Social Cooperation* (Durham, NC: Duke University Press, 2013); Suzanne Lacy, *Mapping the Terrain: New Genre Public Art* (Seattle, WA: Bay Press, 1996); Claire Bishop, "The Social Turn: Collaboration and Its Discontents," *Artforum* 44, no. 6 (February 2006): 178–83.

3 Schultz was formerly the Curator of Public Practice and Director of Education at the Walker Art Center and currently serves as Executive Director of the American Craft Council (2019).

4 Nina Simon, *The Participatory Museum* (Santa Cruz: Museum 2.0, 2011), 5.

5 Ibid., i–v.

6 With Aono, we shared with our partners that her installation would be built through audience participation. With Watt, we shared that one completed artwork would be present at the start of the exhibition, and she would create another piece based locally and in collaboration. This became *Companion Species: Ferocious Mother and Canis Familiaris*, described on page 43.

7 *Relics from Camp* is currently on permanent display at the Japanese American National Museum in Los Angeles.

8 Tom Shapiro, *Campus Art Museums in the 21st Century: A Conversation* (University of Chicago, IL: Cultural Policy Center, 2012).

9 See Michael Rohd, "Five Criteria of Civic Practice," Arts Alliance One State 2015, Session 3, https://vimeo.com/141286662.

10 Ibid.

11 See Dave Cormier's reading of Gilles Deleuze and Félix Guattari's concept of rhizomatic learning from *A Thousand Plateaus*. As he describes, "The whole idea of rhizomatic learning is to acknowledge that learners come from different contexts, that they need different things, and that presuming you know what those things are is like believing in magic. It is a commitment to multiple paths. Organizing a conversation, a course, a meeting or anything else to be rhizomatic involves creating a context, maybe some boundaries, within which a conversation can grow." Dave Cormier, "Rhizomatic Learning — Why we teach?," *Dave's Educational Blog*, November 5, 2011, accessed October 11, 2018, http://davecormier.com/edblog/2011/11/05/rhizomatic-learning-why-learn/. Also, see Chloe Humphreys's reading of Deleuze and Guattari's concept of rhizomatic learning from *A Thousand Plateaus*. As she describes, rhizomatic learning is "to grow away from a pedagogy based on a linear, top-down approach in which apical knowledge is represented and finite, and move toward a pedagogy in which learning is a horizontal, diagonal, and axil process that involves continuous engagement with the unknown." Chloe Humphreys, "Rhizomatic Writing and Pedagogy: Deleuze & Guattari and Heidegger," *The Journal of Educational Thought (JET) / Revue de la Pensée Éducative* 46, no. 3 (Winter 2013): 191–205.

12 As described by Andy Kaplan, educator and scientist Bertram Bruce argues, "Democratic education will move into the future most successfully by treating the community as the curriculum. The interpenetration of the school and the community lies at the heart of democratic education. Bruce asks us to consider a natural model of this inter-dependence in the dynamics of lichen. We learn not just in but through connection: the interactions are vital." Andy Kaplan, "Editor's Introduction: Democratic Learning," *Schools* 15, no. 1 (Spring 2018): 1–8.

13 There was little, if any, debate during these exploratory conversations (which is not always the case). We hypothesize this was due in part to self-selection and shared investment in questions of social justice on the part of meeting attendees. Look to reflections throughout this book for perspectives on our process.

14 Sustained Dialogue (SD) is a Northwestern student-facilitated program that encourages conversation amongst students across lines of difference.

15 The Native American Outreach and Inclusion Task Force at Northwestern was established in fall 2013 to recommend strategies to strengthen the university's relationship with Native American communities through recruitment efforts, academic programs, and campus support services. Their work included reviewing the outcomes of the John Evans Study Committee, which had researched the history of John Evans, one of the founders of Northwestern University. Specifically, it examined the nature of Evans's involvement in the Sand Creek Massacre of Cheyenne and Arapaho, which occurred in 1864 while he was Governor of what was then the Colorado Territory and his relationship then and later with Northwestern. For more on Marie Watt's *Companion Species: Ferocious Mother and Canis Familiarus*, see page 43 of "If You Remember, I'll Remember" in this volume.

16 This quote comes from an interview of Marie Watt conducted by Bielak, Dees, and Watkins on October 4, 2017.

17 Issei, Nisei, Sansei, Yonsei, and Gosei are Japanese terms used to refer to first, second, third, fourth, and fifth generation Japanese Americans (or Japanese in diaspora around the world). Due to the specific temporal restrictions on Japanese immigration in the early part of the twentieth century, these generations also correspond closely to American generational cohorts (Lost Generation, Greatest Generation, Baby Boomers, Gen X, Millennials).

18 Aono and Watt respectively visited Laura Hein's First-Year Seminar in Asian Languages and Cultures; Kelly Wisecup's Topics in Native American and Indigenous Literatures: Louise Erdrich, Winona LaDuke, and Great Lakes Native American Writers; and Rebecca Zorach's Art, Ecology, and Politics seminar.

19 This included selections from Layli Long Soldier's *WHEREAS* and from Solmaz Sharif's *Look*. As described by Long Soldier, *WHEREAS* is in part a response to the Congressional resolution of apology to Native Americans, which President Obama signed in obscurity in 2009. In Solmaz Sharif's collection *Look*, she "asks us to see the ongoing costs of war as the unbearable loss of human lives and also the insidious abuses against our everyday speech." Layli Long Soldier, *WHEREAS* (Minneapolis, MN: Graywolf Press, 2017). Solmaz Sharif, *Look* (Minneapolis, MN: Graywolf Press, 2016).

20 See also pages 87–91 and 93–99 for their perspectives.

21 Marie Watt, unpublished interview with the authors and Janet Dees, October 4, 2017.

22 Ibid., 21.

23 Vialla Hartfield-Mendez and Meghan Tierney, "The University Museum and Community Engagement," *Imagining America* 1, no. 1+2, accessed February 14, 2019, http://public.imaginingamerica.org/blog/article/the-university-museum-and-community-engagement-a-case-study-of-the-michael-c-carlos-museum-at-emory-university-and-the-atlanta-hispaniclatino-community/.

24 For example, there was great interest in having students and members of the Japanese American community in Chicago who had survived internment assist with the installation of Aono's piece, but this wasn't possible due to the complexity of the installation and the tight schedule Aono and our preparators were under. In fact, Aono's second campus visit required nearly complete focus on the installation process, despite our intentions that she reconnect with various communities at that time. We then calibrated so that her on-site engagement work would largely occur on her third visit. With Watt we made similar shifts when it became clear that the installation of her commissioned piece *Companion Species: Ferocious Mother and Canis Familiaris* would take more time than expected.

25 Ibid., 21.

26 Asian Pacific American Coalition and Sustained Dialogue recruited students as moderators during the Deru Kugi Wa Utareru program. After that, Sustained Dialogue organized a monthly pop-up conversation in the gallery, inviting fellow students to dialogue about immigrant and American identities.

27 Randall Szott, et al., "Growing Dialogue: What Is the Effectiveness of Socially-Engaged Art," in *Public Servants: Art and the Crisis of the Common Good*, ed. Johanna Burton, Shannon Jackson, and Dominic Willsdon (Cambridge: The MIT Press, 2016), 457.

INTERVIEWS

EDITORS' NOTE
The following conversations have been transcribed and edited from exchanges
that took place between the interviewees and Block Museum staff after the close
of the exhibition *If You Remember, I'll Remember*.

A significant component of *If You Remember, I'll Remember* was the
development and implementation of engagement projects with artists
Kristine Aono and Marie Watt and in dialogue with their work. In this
section, four stakeholders from outside of the museum reflect on their
involvement in these projects as participants and collaborators.

Ninah Divine and Anna Takada were key partners for Marie Watt's
sewing circles and the Day of Remembrance program, respectively.
At the time, Divine held the role of Coordinator, Native American
and Indigenous Peoples steering group, Office of the President at
Northwestern University. She became an important collaborator in
developing projects with Marie Watt and creating connections to
Native American organizations on campus and in Chicago. A graduate
student fellow in the Office of Multicultural Student Affairs, Takada
was a critical partner in developing connections to student life writ
large and in working with Aono and Japanese American communities
on and off campus. Both Divine and Takada speak to how their
involvement with these projects intersected with their institutional
roles and preexisting personal commitments, and they also offer
critical feedback on the collaboration process in the museum context.

Melissa Blount, psychologist, community activist, and co-founder
of M.E.E.T. (Making Evanston Equitable Together), discusses how
participating in sewing circles with Marie Watt impacted her and was
pivotal in her development of the Black Lives Matter Quilt project. Lisa
Doi, a community activist who currently serves as president of the
Japanese American Citizens League's Chicago Chapter, reflects upon
the experience of serving as a facilitator for the Day of Remembrance
program, which was anchored by intimate group discussions with
Japanese American internment camp survivors.

The interviewees recognize The Block for its commitment to
bringing multiple voices to the table in work based in reciprocity and
for how these projects engaged a diverse cross-section of people in
intergenerational dialogue and fostered intercultural connections. At
the same time, they advise that the museum's efforts in social justice,
diversity, inclusion, and equity need to be as directed towards its
internal structures as they are to engagement with the community.

Marie Watt, *Companion Species: Ferocious Mother and Canis Familiaris* (detail), 2017.

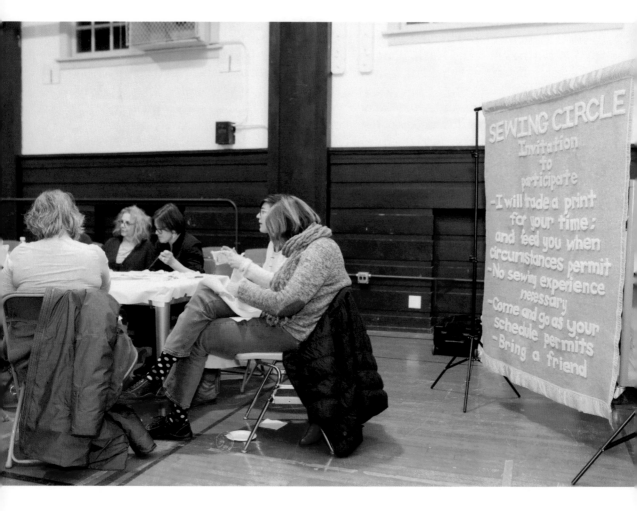

Community members at the Equity Sewing Circle with Marie Watt, organized by The Block Museum of Art, February 8, 2017.

INTERVIEW
Ninah Divine

JANET DEES Thank you for taking the time to participate and revisit the project with Marie Watt and the *If You Remember, I'll Remember* exhibition even after moving on to your next professional chapter. Can you speak about why you were interested in getting involved with this project in particular?

NINAH DIVINE There were a couple of reasons why I was happy to dedicate time and participate in the project. One was a kind of excitement that there was going to be an investment in Native artists, and that the investment wasn't coming from the Office of the President or from One Book One Northwestern or from a particular Native student or faculty member. At the time, I was serving as the coordinator of the Native American and Indigenous Peoples' steering group out of the Office of the President. In this role, I facilitated relationship building with Chicago's Native American community and the organizations within it. This meant coordinating events, meeting to discuss impacts of the John Evans report, and getting input on future plans to address Native American inclusion at Northwestern.[1] I also worked within the various departments and schools at Northwestern to grow the representation of Native and Indigenous people on campus—in the physical landscape, in courses, in research programs. I was excited that the idea came up independently of our efforts.

 The second thing was how central the ideas of reciprocity and community engagement were to the project. It was a driving force in Marie Watt's work and in what the museum undertook overall with this project and the exhibition.

JD Were there any other things about the project that resonated with you? Beyond the approach, what other stakes or issues raised by the project resonated with you?

1 For more on the John Evans report, see note 15 on page 82 of "Imprint of Exchange" in this volume. The full report can be read online: https://www.northwestern.edu/provost/about/committees/study-committee-report.pdf.

ND On a personal level, it was exciting that there would be representation of Native American art through Marie Watt's participation, and also that the discussions were not stereotypical or focused on colonialism or some denigrating history. We were looking at modern Native people, Native artists, and what they're doing today that is relevant to everybody and to a community like Northwestern's.

I spend so much time talking about really tough histories—constantly bringing up colonialism and other forces—and it was exciting that there would be another point of view and an opportunity to connect with an established Native artist who has such an interesting practice to learn from.

JD In addition to spending time with us working on the organization of the project, you took every opportunity to spend time with Marie herself. Is there anything that you'd want to share about your involvement or interactions with her in particular?

ND At first I had some opportunities to interact with her as part of a larger group during lunches or when we showed her around campus. I found it really fun to talk about the breadth of her interests, the things that inspire her, and the things that she wants to know. We'd go from talking about the art project and where she grew up to talking about medicinal plants, the landscape, and what our campus looks like in a physical sense. I always want to interact with other Native people, and it was meaningful to see what drives her and her work on a personal level.

JD Could you talk about your involvement in the project: what was your role and what did you do over the course of the project?

ND As I mentioned, at that time I was serving as the coordinator of the Native American and Indigenous Peoples' steering group. There was a pretty big group of us from different campus units involved, from Neighborhood and Community Relations to Multicultural Student Affairs. I was working on the creative side, bringing in new ideas and thinking about how to expand the project and carry it out. I was there the day of coordinating and helped with sewing. I also was able to provide a number of different connections to the Native community in Chicago to strengthen the event.

JD Were there any particular issues that arose for you over the course of working on the project that you want to speak to—things that you thought went well or things that could have been done better either from our side or any other aspect over the course of almost a year?

ND The longitudinal investment was really awesome. There was, I think, a very small thing. At one of the planning meetings, we were talking with The Block and some of the other partners about how to hold these difficult conversations, what kinds of conversation starters there should be, and what kind of dialogue we hoped would take place during the event. There was a large impulse by some of the partners to pull the conversation away from Native representation and out of Native identity. I think that was because we were hoping to get wide participation and thought that the event should resonate with lots of different people from lots of different places. There was a little bit of tendency to dilute the issues and dilute the Native aspects of the work. It didn't end up being too big of an issue, but I did have a minor concern along the way that it would turn into something more generic than what her project deserved.

JD After participating in the circle itself, did you feel that your concerns were manifested? Was that part of the planning process, or do you feel like that was still a concern in the way that the project was produced and received?

ND I don't think it came to light at all at the actual event. Marie's huge strength was that she helped dialogue and relationships form organically. It wasn't an issue I saw play out during the actual event or even later when her work was put up and people came back for the unveiling. It ended up being a preliminary concern.

JD There was so much happening in the moment socially and politically. Maybe that was pushing people with a kind of urgency in certain directions, but it course corrected itself in the actual way the work played out.

ND Yes.

JD I can understand that. Our commitment to working with Native artists is a commitment, not a one-off, and we also have a commitment to be socially engaged. As we go forward with this work, are there things that you think that we should keep in mind, consider, and be aware of?

ND Getting as many different partners and voices to the planning table, as you did with this project, is the number one way to ensure it has a reciprocally beneficial outcome for the community and for The Block. The most important things to consider are: Whose voices are at the table, and what is the process of developing the event? Is the process itself allowing diverse voices to be heard?

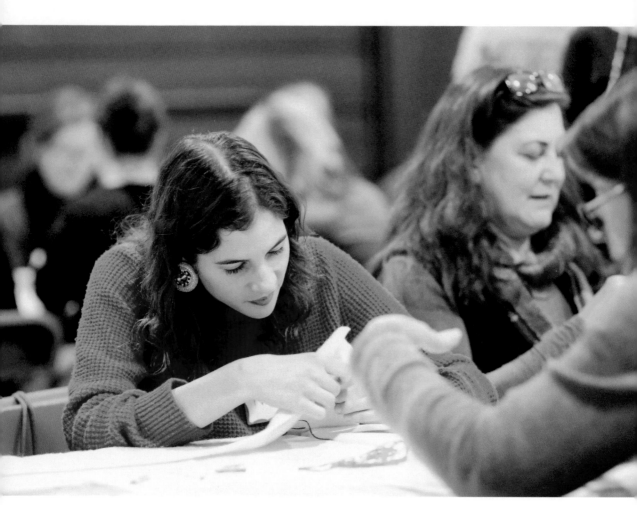

Ninah Divine (pink sweater) and other community members at the Equity Sewing Circle with Marie Watt, organized by The Block Museum of Art, February 8, 2017.

JD I know that you've moved in a different direction in terms of your professional life—going back to medical school—but that you're still active in many different ways with Native communities and Native issues. Is there anything from your experience working on this project or from working with Marie that stands out for you as particularly meaningful?

ND I remember how much fun it was at the actual sewing circle. How the night really flew by. It was so cool to be surrounded by different people having what felt to be incredibly organic conversation and to be contributing toward a project that we all got to see and visit as part of the greater *If You Remember, I'll Remember* exhibit.

The biggest takeaway was the opportunity to see and be a part of really organic community collaboration that contributed towards a collective outcome, which you don't usually see. Typically, community

comes and watches but they don't give anything back to the university or to a speaker or to an artist. This is such an interesting model of how community can contribute something tangible and important to an institution like Northwestern in a way that benefits both.

JD And the way—it seems that you are saying—that there was true reciprocity? That it wasn't one-way, but that there was actually something collective and that both sides benefitted from it. The ability to see that reciprocity concretely in the artwork and the opportunity to come together again also sounds like it was important to you.

ND Yes, exactly.

JD Is there anything else that you'd want to add about the project or experience?

ND My only thought after the fact was that I wish we could have done another sewing circle that was in the community and not on our campus. There's something really powerful about meeting someone at their home in a different part of the community. It's a very mobile activity. It isn't tied to one place. Being able to follow the community home and do it in another location would have been really powerful, too, in terms of that reciprocity and the investment on both sides. I remember seeing sewing circles come up in the community after that happened on campus, so I think it was really well-received and it continued throughout the community after that.

JD Yes, and there's one participant, Melissa Blount, who we also interviewed, who worked with the organization Making Evanston Equitable Together and formed a sewing circle around Black Lives Matter quilting.

ND Yes, that's awesome.

JD So it seemed that, after participating, people took that form back to various aspects of the community to address issues that were of interest to them.

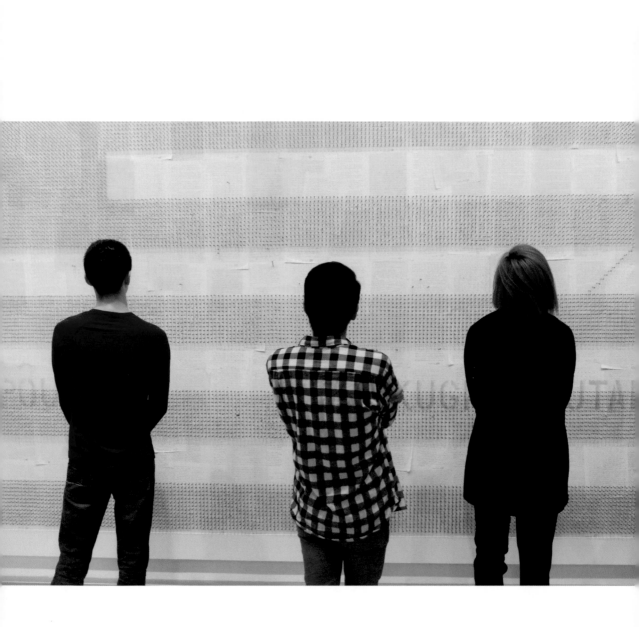

Kristine Aono, *The Nail That Sticks Up the Farthest...* (detail with visitors). Installation view at The Block Museum of Art, 2017.

INTERVIEW
Anna Takada

LAUREN WATKINS My first question is, What made you interested in getting involved in the *If You Remember* project at The Block?

ANNA TAKADA As I recall, Christine Munteanu, Assistant Director of Multicultural Student Affairs (MSA), let me know about the exhibition and that you all had been in touch. Christine knows me well because I worked with her as a graduate assistant. I was grateful to learn about the exhibition because I'm interested in both museum work and the history of the incarceration of Japanese Americans during World War II. I only got more interested as we continued discussions about engagement with the show and with Kristine Aono's piece specifically. It connected not only to some of my professional interests, but also to the work that I do in the Japanese American community. It was different worlds of interest living in one space. It seemed natural that I would be the liaison between The Block and MSA.

LW Would you talk a little bit more about the origin of those points of interest?

AT I would say it starts with the incarceration experience. I got a cultural studies degree, focusing on Asian Pacific–American studies and Africana studies. Those interests came from my own experiences as a kid being frustrated by the erasure and silencing I saw around that history—and wanting to do whatever I could to promote knowledge of it and make sure people are aware of it so that it never happens again. That's really what drove my interest. Also, as a Japanese American, I felt a responsibility to promote awareness about this history.

I've been interested in museums because I think that's one way to do that kind of awareness and advocacy work, and to share different stories, and to educate people who might not necessarily have access to that information in school. I think that goes hand in hand with my community involvement. I don't know which came first, my involvement in the community or this particular interest in museums, but they're related.

LW You mentioned that you served as a liaison between Multicultural Student Affairs and The Block throughout this project. How did you see your role?

AT In the early conversations with you, Susy, and Kristine, and the different partners and community stakeholders, my role was representing how we could engage with Northwestern students. Particularly, I would say, students who use MSA—students of color, LGBTQ students. By having that MSA presence, we had a direct connection. Given that The Block is a museum of Northwestern, it made sense to build that relationship with MSA to try to engage with the people who were actually on campus and hopefully coming into the museum.

LW In addition to students, though, you also held relationships with community partners, and your relationships and work with both of these constituencies was critical in making multifaceted programs happen, most notably the Day of Remembrance [DOR]. Can you describe what this day was and how it came about?

AT The Day of Remembrance program at The Block was really special. Each year, the Japanese American community hosts the commemorative Day of Remembrance program to acknowledge the signing of Executive Order 9066, which authorized the incarceration of some 120,000 Japanese American citizens and residents during World War II.

This seemed to be a perfect opportunity to make a more robust program, especially because it was the seventy-fifth anniversary, and given [Donald] Trump's recent inauguration and the egregious executive orders signed within the first month of his presidency.[1]

LW You and I talked a lot about how this would be an opportunity for people who had been incarcerated, who have lived through this history, to share their very personal experiences in a public forum.

AT The idea to provide a platform for Nisei to share their stories originated in the desire to honor those who had actually lived through the incarceration.[2] Also, in recognizing that 2017 would be the last landmark anniversary that most Nisei would experience, the Day of Remembrance planning committee and The Block agreed it would be fitting to share first-hand stories of World War II incarceration. Many past DOR programs have featured short films, plays, poems, and other means of storytelling, but it felt natural to make this year's program centered on the voices of those who were directly affected by the incarceration.

And so it went from being just a day-long, or hours-long, program to a full weekend of remembrance—the first time ever in Chicago's Japanese American community. The first event took place at The Block, and the standard program occurred the following day at the Chicago History Museum.

The Block program began with opening remarks and an introduction to the annual Day of Remembrance program. I read a letter from Kristine Aono to welcome guests and introduce her featured installation, *The Nail That Sticks Up the Farthest...*, which participants would be invited to engage with following the program. After introductions, we divided participants into six groups led by students and young people from the Japanese American community. Each group settled in different parts of the museum—most of which met in the gallery—and listened as Jane Hidaka, Yuki Hiyama, Enoch Kanaya, Jean Mishima, Jim Mita, and Merry Oya shared their experiences of incarceration and/or military service during World War II. The program was centered on these stories, and groups were encouraged to engage in dialogue with the speakers and each other. Following these discussions, participants were invited to view Kristine Aono's installation and the documentary *History and Memory: for Akiko and Takashige.*

It was some of the best attendance that there has ever been to any Day of Remembrance program.

LW Your connection to the partners from the Japanese American community was key. Would you describe the process of getting them involved?

AT It was kind of strange, to be honest, because I was working with people in the community who I would have been working with regardless of my position at Northwestern. But it was fun to have these two worlds come together.

I felt like a representative of the museum itself and what was happening here. It did take some gentle nudging because sometimes people don't like change: change is scary, or risky, or a lot of work. But I tried to frame it as exactly what it was, which was, "This is already happening, let's work together on it." Everyone was on board, and excited, and energized. I think it was really exciting for people from that community and the committee to work with this new partner [and] a whole different audience.

LW After we landed on this form for the program, I remember we quickly seized on the idea of having others, specifically students, help moderate the conversations that would happen.

Anna Takada, Fellow at Northwestern Multicultural Student Affairs, with her father, Michael Takada, Chief Executive Officer of the Japanese American Society of Chicago at the program Deru Kugi Wa Utareru: Stories of Internment and Remembrance, The Block Museum of Art, February 18, 2017.

AT I think moderators were important because the internment is a difficult thing to talk about. Some people haven't spoken publicly about it. I specifically remember one of the Nisei speakers asking me, "What is the size of the group?." She had never shared her story before and she seemed a little anxious. Moderators became essential when we decided to divide into smaller groups that would feel more manageable for participants. We were literally corralling two hundred people, and the moderators were extremely helpful, welcoming each group and then taking them to different parts of the museum.

There were a couple of other intentions behind bringing in moderators. One was to make sure that the conversation was flowing. Moderators were folks who we could trust to step in if the conversation was slowing or, let's say, if someone made an inappropriate comment. There was somebody there who could take control of the situation and who could keep the dialogue going.

We also wanted to create a space for intergenerational and cross-cultural dialogue. Given the significance and relevance of the exhibition's themes—love, mourning, war, relocation, internment, resistance, and civil rights—as well as of the Day of Remembrance, we hoped to facilitate meaningful dialogue between those who

survived such experiences and those who may be fighting injustice today. We wanted students to be a part of that. It was another mode of engagement to get folks on campus involved with what was happening here and to engage in the show beyond just visiting it. We wanted them to join us in creating a dialogue around the show.

LW Will you speak a little more about this desire for intergenerational dialogue? We've been reminded that creating platforms for intergenerational dialogue was something that kept coming up [in planning]. Why do you think this became so important to the project?

AT Given that *If You Remember, I'll Remember* connects works that are in conversation with past historical events and trauma, intergenerational dialogue was a recurring theme and desire from the planning side of programming. The best way to connect with such events is through the people who lived through them and hearing about these experiences first-hand. People are the most powerful connection to the past. Through dialogue, we can learn what happened while making connections to present-day experiences. We can assess and analyze while in community with one another.

 Specifically in regards to the history of World War II incarceration, intergenerational dialogue is a common theme in the Japanese American community. I think this is likely due to the fact that the impact of the incarceration was and continues to be intergenerational and that trauma created by this experience is often "handed down." Moreover, the incarceration was most often considered a taboo subject in the home until the years following the civil rights movement, when the fact of the incarceration grew less stigmatized among families— and with the consequent signing of the Civil Liberties Act of 1988. Today, however, many Nisei find it important to share with families and younger generations to ensure nothing like the incarceration happens ever again, to any group of people.

LW What are the ripples for you, personally, from the whole arc of the experience? How has it impacted you?

AT For me, personally, I think it was a great example of how to activate a museum space and engage with the community, not only of Northwestern but of those who might see themselves represented in the show. It's an example of how to hold an alternative exhibition space where rather than just presenting information and calling it a day, the work is being done by visitors, those coming to see it.

 I think the pieces chosen and programs organized challenged visitors to contribute something of themselves, which few exhibitions require. I saw this with Kristine Aono's, Samantha Hill's, and Marie

Watt's pieces. Whether inviting visitors to physically alter the piece in an act of commemoration or offering a timeline in which visitors will inevitably make connections for themselves of past and present, these pieces are not only on display but extend invitations to engage. Similarly, programming like Marie Watt's sewing circles prompted guests to literally "do the work" to create a piece. The artistic and conceptual intentions were there too, as participants worked with one another to create works around dialogue about themes like "equity."

For the exhibition as a whole, visitors were challenged to see the thematic connections between different pieces, regardless of time, place, or community directly impacted. That's what a good or an effective exhibition does—it makes people do the work so that they'll leave with a better understanding of whatever it is about. In this case, it was leaving with a better understanding of a very American experience of violations of civil liberties, trauma, and memory.

That's really special, and that's something that I will probably take with me as I explore a career in museum work or exhibitions.

LW You are currently in a role where you are doing that work in a different organization. Can you talk a little bit about your present work and what threads emanate out of your experience here at The Block?

AT In my current position, what I've taken is a very dialogue- and reflection-based approach, specifically with the oral histories that I'm recording. By conducting an oral history, I'm prompting people to recall and reflect. And I've also not only been interviewing folks who were actually interned and who came to Chicago, but folks with no direct relation to this history.

LW Why is this practice—of dialogue and inviting people to reflect— important to you and to your work with social justice?

AT The practice of dialogue and reflection is important because in many cases I think it has the power to heal. When we recall an event or a feeling we are prompted to reconcile with it, often viewing it with perspective. Especially when in conversation with someone else, with another person hearing and responding, these meditations become more than just a thought kept to oneself. They become "real" or validated and must be addressed. In this way, I believe there is much potential for healing in dialogue and reflection, which I think is a critical component of any kind of social justice work. In order to move forward and effect true social change, it is necessary to confront and analyze the past.

LW If The Block continues with this kind of work, which we hope to do, what kinds of things do you think we need to consider going forward? Are there issues to address? Approaches to refine? Questions we should be asking ourselves?

AT In considering this question, the first thing that came to mind was, What does The Block control in the first place that could be a simple way to start this work? And I think that's institutionally. I imagine that, before you even go out and try to do social justice work, there are ways you can change from within to be more progressive and equitable. When I think about the situation at my current place of employment, for example, I'm on an exhibitions team of six members and I'm the only person of color on a show about Japanese American internment. In brief, I'll mention that there has been frustration among gallery staff as some people were promoted for this current exhibition, while others were not. Personal identity and how it impacts opportunity is often noted in these casual conversations among staff. It's interesting to work within an organization that really claims and projects to be about social justice and equity when, even within its own staffing, it's not reflected there. So that's one of my recent meditations—how can you start from within before you go out and say, "Hey, community of color, help me promote social justice and equity through my work." Which happens all the time.

LW It connects back to the idea that you were talking about earlier: do the work, don't just receive or proceed. Do the work of actively reflecting and, for an institution, actively take on the questions: Who are we? What do we really care about? How do we operate? That comes first.

AT Exactly. It's important in social justice work to consider concrete steps forward and offer options for individual commitments to the issues and work at hand. Of course, while one step is to provide programming that educates and fosters community development, true social change will only happen through continued commitment.

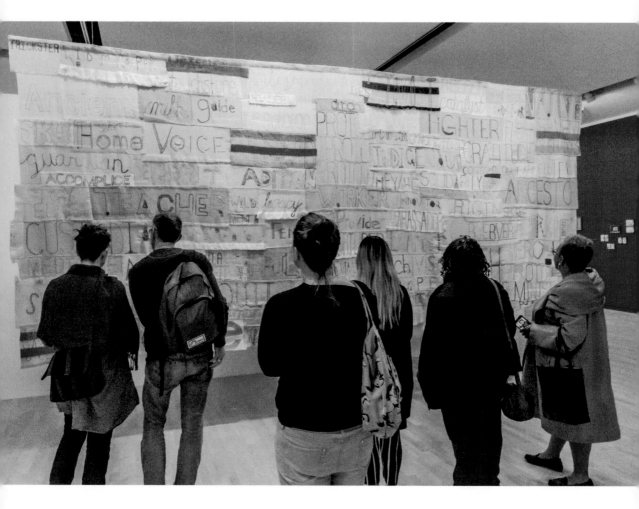

Visitors at the unveiling of Marie Watt's *Companion Species: Ferocious Mother and Canis Familiaris*, 2017. Reclaimed wool blankets and embroidery floss. Commissioned by The Block Museum of Art (now in the collection of the Portland Art Museum, Portland, Oregon).

INTERVIEW
Melissa Blount

JANET DEES Thank you for participating and taking the time to do this. I know that you came to the exhibition and also spent time in Marie Watt's sewing circles. The first thing I want to ask is, What prompted you to attend the event and how did you hear about it?

MELISSA BLOUNT I'm always on The Block Museum Facebook page or am deliberately looking for things to do over at Northwestern. I'm not sure if I found out about it that way, or if someone told me about it because I love sewing. I love the notion of quilting and had the idea of gathering folks together to work on a quilt, so when I heard about the sewing circle, I thought: I have to go to this. Reading about Marie's work and learning about the depth of meaning behind the project also prompted me to participate.

JD You mentioned your own quilting project. Can you talk a little bit more about the idea behind your quilt and how that directly resonated with your experience with Marie?

MB I had been trying to figure out how to do a Black Lives Matter quilt, but I couldn't wrap my head around how to put it into perspective given the enormity of the problems with respect to police brutality and the number of killings. I didn't know how to put it into context or even how the quilt would look.

But then a couple of things happened around the same time. My husband [Ben Blount] created a piece memorializing the Black men who'd been killed in Chicago in 2016. And, then, Marie Watt's circle happened.

Those two things together helped me to firm up the idea around our quilt, which was to focus on Black women who had been killed in the city in 2016. Once I started the project, other issues emerged around domestic violence and other violence against Black women. Living where they lived put these women at risk. That helped us say, Hey, we should keep it going beyond 2016. This is an ongoing issue and not many people are talking about it.

JD You also founded the organization Making Evanston Equitable Together (MEET). Can you talk a little bit about that work and how the quilt fits into the larger work that you've been doing?

MB It's kind of a loose organization, but really passionate. On Mother's Day weekend in 2015, we all got together to have a vigil in solidarity with a bunch of mothers who'd gone to Washington to march.[1]

At that time we thought, How can we make this issue really visible and spread it across the city? What can we do in our own little city to highlight Black Lives Matter and to humanize the movement? I was really disturbed by how controversial it was becoming. UCE, the Unitarian Church [of Evanston] in town, had already begun selling Black Lives Matter signs, but they hadn't had a broad reach and appeal. So we got together and said, We're going to cover all of Evanston so that everywhere you look, there will be Black Lives Matter signs.

Eventually people asked, Well, what do you call yourselves? Who are you people? I like things that are easy to remember and have meaning, so I came up with the acronym "MEET." We wanted people to get together to meet and discuss the issues raised by Black Lives Matter, to discuss what having a sign in your yard meant. What did it feel like? Did it initiate conversation? Did people find it controversial? We've been doing that for the past two years.

There really isn't a lot of structure to it, and we said we were going to end the sign distribution this past Mother's Day [2017], but people have been vandalizing the signs and defacing them or taking them. And so we said, You know what, we really should keep it going. So, along with the circles, we're going to continue distributing the signs.

JD Can you point to anything about the experience of Marie Watt's sewing circle that clicked for you? What did you take away from that and how did it impact you?

MB There were two things. One, I was struck by the number of women who showed up. There were certainly men at that circle, too, but it was just such a huge community of women, and the group was so diverse. I go to events organized around issues of equity or other social justice issues that some people label as controversial, but aren't. You have certain players that show up at all of these events, and the events are often predominantly white. So I was struck at how diverse the crowd was.

Then, I was struck by the depth of the conversation and how immediate the connection was. At the end of it, people didn't want to leave. You all must have had to kick us out. People were saying, Let's stay in touch. I don't want to sound too dramatic about it, but I really do mean this: Marie Watt's sewing circle changed my life. It was a

transformative experience. I was struck by the genuineness of the act of coming together at a time when we were all feeling vulnerable after the election.[2] And after we knew we wouldn't see the first woman president, it felt very powerful to have women gather like that.

JD Has this continued in the Black Lives Matter sewing circles?

MB Oh, for sure. I'm struggling with how to have that kind of diversity in participants, but the quality of the circles and the impact, I think, is similar. I've been really pleased and humbled by that. The circles have helped maintain a sense of hope despite all of this death that continues to happen.

JD A lot of museums across the country are starting to pay attention to issues of social justice and integrate that attention in various ways within their institutions. I am curious to hear if that's something that you've seen or thought about, or if you've thought about this in relation to The Block in particular.

MB I think The Block has an interesting opportunity and sits in an interesting place because you're so accessible and there's an intimacy to the museum that other cultural institutions don't have. It makes a huge difference that admission is free, and that you show works of high quality. I don't see many [museums] across the country trying to engage the community around really difficult subject matter. This has been the first place I've lived where I've seen a real intentional effort on the part of a museum to reach to out the community and to be successful at it. I think Northwestern as an institution struggles with that, but I think you all [at The Block] have made it very easy for the community to access the museum.

JD So if we continue in this vein going forward, which is a commitment that we do have, are there things that you think we need to consider? You have talked about what we do well. Are there things that you think we could do better? Are there things that we might need to keep in mind as we seek to be inclusive and expand our audience?

MB You already work with Youth & Opportunity United (Y.O.U.).[3] I don't know how closely you work with the high school students, but it would be great to engage the middle schoolers, too, or maybe even educators in the district.

Maybe it could be possible to work more closely with the school district—because it is such a small community—to get some kind of synergy going.

Melissa Blount at the Black Lives Matter Witness Quilt Sewing Circle, organized by Blount and The Block Museum of Art, January 31, 2018.

JD We've done this on a small scale—partnering with Y.O.U. to go into classrooms for a specific purpose. Part of the issue is staffing. I don't think there's a lack of desire, but we do constantly think about how to do the most with the human resources that we have. But maybe there is a way of doing something like a big movie screening as a program outside of The Block. That's a really good point.

MB We're trying to get the middle school to show the documentary *13th* but it is being labeled as controversial. We are thinking, Are we being seen as Black Panthers for wanting to show this? That's the feel around it. But I'm wondering what would happen if we said, Hey, The Block Museum wants to screen this. That could add some kind of validation and buffer. I hate that you even have to say that because the work is the work, but packaging does matter. How you introduce things to people, how things are framed, matters. That's the thing, Janet, you—the museum—have the ability to frame issues that people

might distance themselves from. Art and cultural institutions have a way of saying, Hey, pay attention to this, in a way that doesn't feel scary for people.

That's the thing that really struck me about Marie's work. She didn't mute what she was doing. She focused on issues of equity, but people still went to the event and you didn't feel divisions between people. It was amazing. If we could do that on an ongoing basis, it would be really powerful.

NOTES

1 The 2015 Million Moms March in Washington, D.C., was organized by mothers who had lost their children to police action killings.
2 2016 US presidential election.
3 For more on The Block's work with Youth & Opportunity United, see page 70 of "Imprint of Exchange" in this volume.

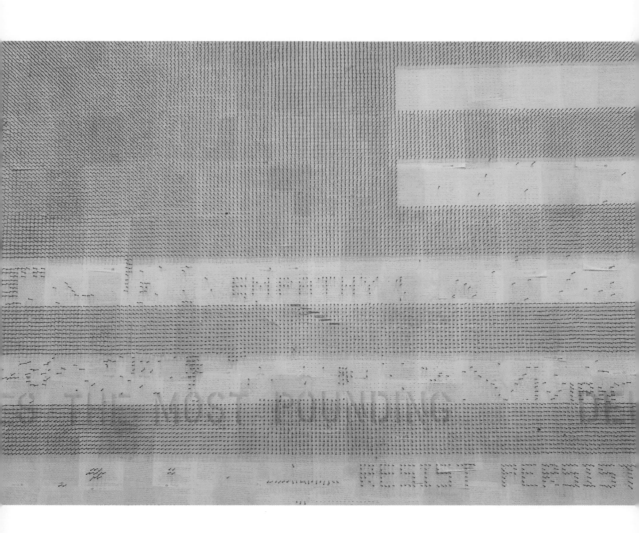

Kristine Aono, *The Nail That Sticks Up the Farthest...* (detail). Installation view at The Block Museum of Art, 2017.

INTERVIEW
Lisa Doi

LAUREN WATKINS Thank you for taking the time to talk with me about your involvement in the *If You Remember, I'll Remember* project, and specifically the Day of Remembrance program that you supported and participated in as a moderator. How did you find out about the exhibition and programming, and why were you interested in getting involved?

LISA DOI Most directly, I heard about the exhibition and programming from Anna Takada, who worked through the office of Multicultural Student Affairs to support the program. She did an excellent job of working with the Kansha Project of the Japanese American Citizens League (JACL) of Chicago to get young Japanese Americans aware of and involved in the exhibition.[1] I also think the exhibition was widely advertised within the Japanese American community around Chicago. The Block Museum did a really good job inviting community members to participate in a variety of ways in the exhibition.

LW What propelled you to want to participate?

LD Well, I grew up in Evanston, very close to campus. But while The Block Museum was something that I had known of, I had never actually been inside of it.

I think the accessibility of the exhibit was really helpful. The title of the show, *If You Remember, I'll Remember,* was a very compelling concept. I think Kristine Aono's piece in particular captured something about the nature of the incarceration experience in a compelling way. In some ways her use of this metaphor of the nail that sticks up the farthest asks questions about what it means to be a member of a community, and what that kind of participation looks like. These are really resonant questions. And then there were a lot of opportunities, specifically for young people, that were very engaging.

LW Can you elaborate a little bit more on that last point? What do you think were the particularly successful invitations to participate for young people?

LD I think creating the role of facilitators for the Day of Remembrance was a positive move. If you are not as connected to the community and sort of nervous about participating, having a concrete task like connecting generations is helpful. Pairing young people, both from within the Japanese American community and from the Northwestern student body, with Nisei speakers was a strong way of inviting people in, both for young people and the Nisei speakers, many of whom were very well-versed and often go to schools and community organizations to talk about their stories, but there were also some who had never done that before.[2]

LW That's a great segue to my next question, which is building on the experience that you had as a facilitator. Will you speak to that, and your larger involvement in that day?

LD It was a great way to expand commemoration events for the seventy-fifth anniversary of the signing of Executive Order 9066.[3] The woman that I was paired with was someone who did not typically share her story. This was the first time that she had ever talked publicly to a group of strangers about her experience of incarceration. That was really powerful for me, especially as we're getting to a point where Nisei are passing away and the opportunity to hear these stories firsthand is diminishing. And, increasingly, the people who are able to tell their stories were younger when they were incarcerated. That tells a different story.

I [recently] heard a talk by someone from Seattle who showed a picture of his great uncle's funeral in camp. His great uncle was a soldier during World War II and died overseas, so they had a funeral service for his family. This picture showed his great grandparents receiving an American flag, and his grandparents, and other people who are gathered for the funeral. Then, in the bottom corner of the image, there are two kids, probably four-year-olds, playing in the sand.

And now only those two four-year-olds are left. Everyone else in that image has died or is no longer able to share their stories, so the stories we're hearing are from those two little children in the corner of that image. Their memory of that experience is likely very different from the memories of the other funeral goers or the memories of parents who lost their son.

It's really important that we continue to listen to people who lived through the incarceration camps but also to think about ways that young people who facilitate for Day of Remembrance are tasked with carrying the story forward. It was important to have those moments of intergenerational work to think about obligations for Yonsei, or fourth-generation Japanese Americans, and others connected to the Japanese American community to take on the story of our

grandparents and think about ways that we are to shepherd it in the future.

The group that I was helping to facilitate at the Day of Remembrance was largely a single, multiracial family with one set of grandparents that had been incarcerated. It was compelling to have this conversation between parents and children about something that happened to parents and in-laws.

So to bring these strands together: What happens when the Nisei are no longer around? What are the obligations of young Japanese Americans to take up these stories? And, then, how do families make meaning of this together?

I think it was eye-opening to be able to hear from someone who was incarcerated. It personalized that story in a very different way than what they had been able to experience before.

LW Were there other surprises or experiences from that day that stick with you?

LD Two things. One, the volume of people who came was tremendous. I also appreciated being able to view the piece with community. So often, if I visit a museum, I would do so alone, or maybe with a small group of friends, or my mom. It was really powerful to be able to see the piece with a whole slew of people who are really important to what my Japanese American community looks like.

And to be able to watch people . . . There was a deep sense of ceremony in placing nails into the wall and in seeing people interact with the exhibit because it was so physical and so immense in its size. It was powerful to have a moment where there was this intentional sense of purpose and a communal feeling about collectively engaging with the piece of art. The connection probably wouldn't have happened otherwise—maybe if there was an event created just for that—but using the Day of Remembrance to do that was a really appropriate choice.

So often the Day of Remembrance can go in different directions. In its name, there's a sense of reflection and introspection, but at the same time, there's often this desire to pull towards political engagement or activism. The event at The Block really sat well within that, offering a sense of ceremony and honoring the memory of people who were incarcerated in a very powerful way.

LW You also had other touchpoints with the project later on. Can you speak to your experiences with those?

LD I think the only thing that would have made "Day of Remembrance" better is getting to meet Kristine Aono, and to look at the piece with

her, and to hear the process through which she created the piece. Because it really is a striking idea and it's a really powerful way to execute this idea. I really liked Anna [Takada] reading [Aono's] letter at the Day of Remembrance, but if she had been there, that, I think, would be the only thing that would have made it better.

I also went to a panel and conversation with Kristine Aono and some of the faculty at Northwestern.

LW The reparations program?

LD Yeah, which was a really phenomenal conversation as well.

LW It did turn into a dialogue that included tending to the specific lived experience of the incarceration but also integrated perspectives from the Native American experience. Were there any parts of that program that resonated with you in particular?

LD I think two things. First, talking about the history of Northwestern and particularly John Evans.[4] As an Evanstonian, I've never thought about who John Evans was. Especially because I think Evanston—and I say this in a kind of tongue-in-cheek way—loves to pat itself on the back for being this liberal, progressive haven. Yet that was a story I'd never heard or thought about until that night.

It was also powerful to highlight the ways that Northwestern, as an institution, has to grapple with its own history. I thought Laura Fujikawa did a great job of linking that history to the history of the Japanese American incarceration, particularly the ways that actual [Native American] reservation spaces were used to confine Japanese Americans. And the double insult of that—to take land again that had already been taken from Native people to use to confine another group of people. Tracing those lineages and the ways that those histories are similar is so powerful because there are certain other ways in which our history gets used all the time; we often place this history in the context of post 9/11, anti-Muslim sentiment.

LW Right.

LD Which is not to say that connection is not important, but there are so many other ways that this history, the history of the incarceration, can apply today. Particularly the topic of reparations, whether that's reparations for slavery or reparations for Indigenous genocide and forced removal. To me, that's a really compelling and under-explored way to interpret this history.

LW I'm curious—has your involvement with this project impacted your work going forward?

LD I think it ushered in a moment of exploring the ways that young people—or just non-Nisei, whether that's Sansei, like Kristine Aono, or Yonsei—are making meaning of the incarceration. It has been a theme this year since the Day of Remembrance program. A local drumming group in Chicago is composing a series of pieces about the incarceration history, written by Yonsei musicians. I've recently connected with a group of Yonsei filmmakers who are creating films, some of which are explicitly about the incarceration. But the projects that I think are most compelling are actually about ways that Sansei and Yonsei have to make meaning of this experience that their parents and grandparents had.

I wouldn't self-identify as an artist, and I am not necessarily particularly artistic, but for so many people art is a deeply resonant thing that often goes beyond the capacity of words to encapsulate emotional meaning. Using visual art, music, or film to tell that story in a different way, or to engage with it in a different way emotionally, has been a theme of the past year, even going into thinking about [the] Day of Remembrance 2018 in ways that are unexpected.

LW I have a question that hooks back to something that you said previously about the Day of Remembrance and how often there is this introspective impulse to both remember and reflect—and also an impulse to take action and engage in experiences that activate a sense of social justice. That's certainly something that came up over the whole run of the exhibition. Social justice is also an ongoing through-line of our work at The Block Museum. Do you have thoughts on the role of an institution like The Block in opening up spaces where these kinds of histories and the connection of lived experiences to the present day can be interrogated? Are there questions we should consider? If we continue with this kind of work, the kind of work that emerged in the context of this project, what should we hold in mind? What might we do better?

LD I would self-describe myself as an accidental historian. Academically I identify as an anthropologist who increasingly worked backwards in time until my focus became history. I think that there's a lot that's wrong with how universities conceive of historical sources. Anthropology is so much more open to radical sources, whereas history is the archive. If it's not in the archive, then it's not seen as true or historically valid. To me, what makes The Block so compelling is that it has a deep relationship to a university. If you take on a social justice mission or have a social justice orientation, there are

really powerful ways that you can disrupt some of those academic epistemological structures to say that a piece like Kristine Aono's or really any of the pieces in *If You Remember, I'll Remember* are valid historical texts. The history department is probably not even a quarter mile away from the gallery. So even if these works of art would not be considered legitimate by all historians, like texts that could be taught in a class, I think there is a wave of historians who would increasingly see that these are legitimate sources of knowledge.

But how do you disrupt the archive? Or how do you disrupt particular systems of knowledge production and elevate different types of knowledge production onto the same plane? To me, that would be the most exciting project.

In the case of the Kristine Aono's piece, I'd like to see ways that it can be integrated into an Asian American studies or history curriculum. Focusing on the ways in which artistic interpretation of—and artistic participation with—memory are avenues for producing and knowing is just as valid as looking into archival sources.

I'm interested in ideas of epistemicide and the ways in which oppression and genocide have killed Indigenous forms of knowing and knowledges of the oppressed. A lot of that means disrupting and inverting institutions that we have given permission to make legitimate knowledge.

LW To continue the thread of this opportunity that you're identifying for us as an institution, does this interest that you have in knowledges of the oppressed, and that act of disrupting traditional hierarchies of knowledge, also extend out to an interest in creating platforms for people's voices and experiences to be elevated and heard?

LD Yeah, absolutely. Similar to the way that giving the young people who were facilitators at Day of Remembrance a concrete task was a helpful strategy to bring people into meaningful conversation having something to respond to, so it's not just a theoretical conversation, but one about a specific piece of art or a film or something else concrete, helps to bring in people who potentially have felt delegitimized in producing and creating knowledge themselves. It can often serve as a starting point for a broader conversation in a way that a lecture or a panel discussion, maybe, would close down that potential. Responding to a piece of art, I think, often allows for an opening up of conversation.

LW Are there any other final thoughts or reflections you would have us at The Block hold in mind based on your experience?

LD The outreach into the Japanese American community for this piece last year was really strong and made people feel welcome. Whether

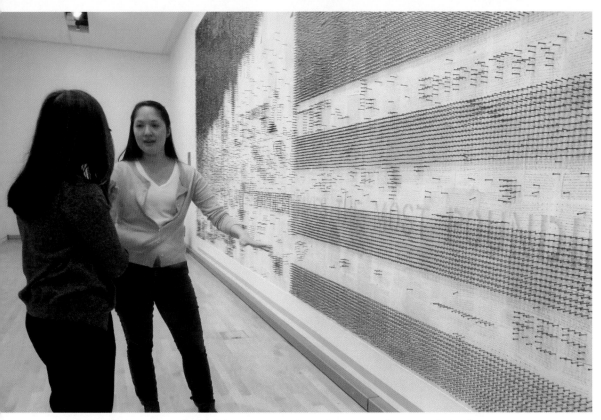

Lisa Doi (yellow sweater) with Kristine Aono, in front *The Nail That Sticks Up the Farthest....*
Installation at The Block Museum of Art, 2017.

that was Anna [Takada] or having someone in a role like Anna's who is independently connected to the Japanese American community—that's a huge asset to continuing socially just programming and making people feel that they are welcome and that this is their space too.

NOTES

1 The JACL Chicago's Kansha Project was started in 2012 to connect young Japanese Americans from Chicago and the Midwest to each other and to the history of Japanese American incarceration during World War II. Each year, a cohort of young people convene in Chicago for an orientation, then travel to Los Angeles's Little Tokyo and Manzanar National Historic Site.

2 Issei, Nisei, Sansei, Yonsei, and Gosei are Japanese terms used to refer to first, second, third, fourth, and fifth generation Japanese Americans (or Japanese in diaspora around the world). See also note 17 on page 82 of "Imprint of Exchange" in this volume.

3 Executive Order 9066 was issued by US President Franklin D. Roosevelt on February 19, 1942. It initiated the removal from the West Coast and incarceration of over 120,000 Japanese Americans for the duration of World War II.

4 See note 15 on page 82 of "Imprint of Exchange" and page 87 of "Interview: Ninah Divine" in this volume.

Installation view, *If You Remember, I'll Remember*, The Block Museum of Art, 2017.

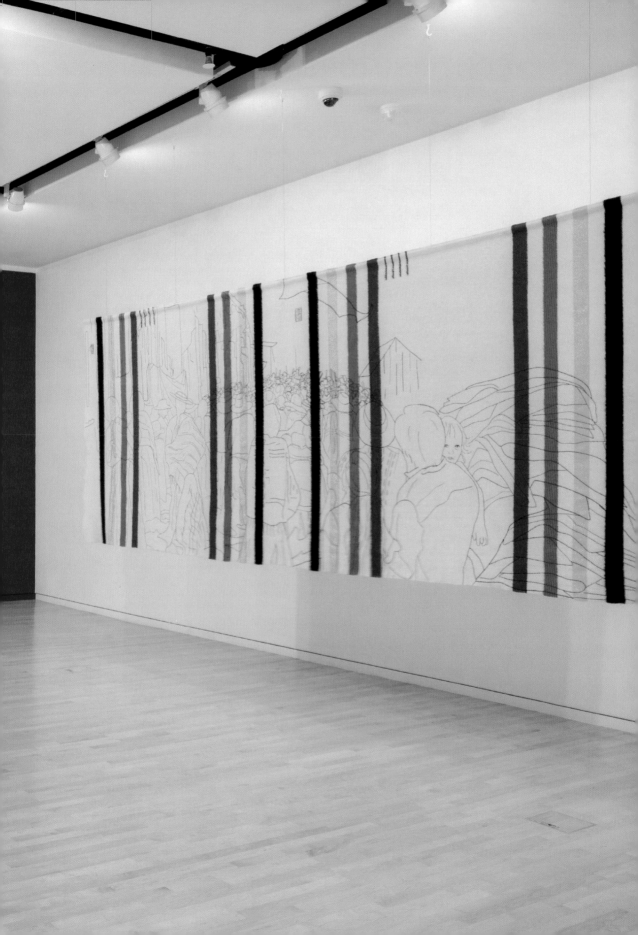

CONTRIBUTORS

SUSY BIELAK is an artist, curator, and educator. She was formerly the Susan and Stephen Wilson Associate Director of Engagement and Curator of Public Practice at The Block Museum of Art at Northwestern University. As head of the Engagement Department Bielak directed a department integrating programming, pedagogy, and partnerships and led artist projects outside of the walls of the museum. Prior to joining The Block, she served as the Associate Director of Public and Interpretive Programs at the Walker Art Center. As a collaborator and platform creator, Bielak has led projects ranging from a symposium on agonism to an Artists' Congress. Approaching universities and museums as interdisciplinary laboratories and civic spaces, she has organized projects with artists including Jen Bervin, Simone Forti, Marisa Jahn, Marc Bamuthi Joseph, the Museum of Non Participation, Mark Nowak, and Dario Robleto.

Bielak's own work has been collected and exhibited widely, including by the International Print Center, San Diego Museum of Contemporary Art, and Walker Art Center. Her work has been published in *Art Papers*, *Poetry Magazine*, and *New American Paintings*, among others. Bielak earned a BA from Macalester College in Art, in Anthropology & Psychology, and an MFA from the University of California, San Diego, in Visual Arts, with a UC MEXUS Dissertation Award.

MELISSA BLOUNT, PH.D., is a licensed clinical psychologist and artist. She earned her PhD in Clinical Psychology from Western Michigan University and her BA in Psychology from Hampton University. Melissa has spent over twenty years studying human behavior, specifically interested in the way racism, gender, and class impact physical and psychological outcomes for communities of color. Most recently she utilizes her background in psychology and the medium of quilting to create textile art that explores notions of trauma, white supremacy, and bearing witness to the unjust violent loss of life in communities of color. Historic and contemporary influences include Ida B.

Wells-Barnett, Frances E. Willard, the Gee's Bend Quilters Collective, Amos Kennedy, Ben Blount, Bisa Butler, Krista Franklin, and Marie Watt. Dr. Blount lives in Evanston with her husband and has the wonderful privilege of being mom to a precious and precocious teenage daughter.

JOSHUA CHAMBERS-LETSON, PH.D., is a performance theorist working at the intersection of performance studies, critical race theory, political theory, and queer of color critique. A Professor of Performance Studies at Northwestern University, he is also the author of *After the Party: A Manifesto for Queer of Color Life* (NYU Press, 2018) and *A Race So Different: Law and Performance in Asian America* (NYU Press, 2013). His academic writing has appeared in edited volumes and journals including *Social Text, Political Theory, Criticism, MELUS, TDR/The Drama Review*, and *Women & Performance*. Art writing has appeared in catalogs for Tehching Hsieh's exhibition at the 2017 Venice Biennale and the Chrysler Museum/Grey Art Gallery's exhibition *Tseng Kwong Chi: Performing for the Camera* as well as in *Dirty Looks, The Brooklyn Rail, ASAP/J*, and the *Walker Reader*. With Ann Pellegrini and Tavia Nyong'o he is a series co-editor of the Sexual Cultures series at NYU Press.

JANET DEES is the Steven and Lisa Munster Tananbaum Curator of Modern and Contemporary Art at The Block Museum of Art, Northwestern University. Prior to her appointment at The Block in September 2015, she was curator at SITE Santa Fe, where she had held various curatorial positions since 2008. Dees was a part of the curatorial team for *Unsettled Landscapes* (2014) the inaugural *SITElines: New Perspectives on Art of the Americas* biennial, and over the past decade has curated several exhibitions and produced new commissions with a wide variety of contemporary artists. Recent projects include *Hank Willis Thomas: Unbranded* (2018), *Experiments in Form: Sam Gilliam, Alan Shields, Frank Stella* (2018), *Carrie Mae Weems: Ritual and Revolution* (2017), *If You Remember, I'll Remember* (2017), and *Kader Attia: Reflecting Memory* (2017) at The Block and *Unsuspected Possibilities:*

Leonardo Drew, Sarah Oppenheimer, Marie Watt (2015), *SITE: 20 Years/20 Shows* (2015), and *Linda Mary Montano: Always Creative* (2013) at SITE Santa Fe. She has contributed to publications for SITE Santa Fe, the Minneapolis Institute of Arts, and the Smithsonian National Museum of the American Indian, among others.

NINAH DIVINE is a graduate of Northwestern University Weinberg College of Arts and Sciences (BA, Anthropology, 2016). Much of her time at Northwestern was dedicated to the Native American and Indigenous Student Alliance where she advocated for Indigenous representation across campus. She later served as the Coordinator of Northwestern University's Native American and Indigenous Peoples Steering Group from 2016–17. Her role facilitated relationships between Northwestern and the Native American communities in Chicago and beyond and increased resources available to Indigenous students. She currently attends the University of Wisconsin School of Medicine and Public Health where she is an affiliate of the Native American Center for Health Professions. As a physician, she hopes to work alongside communities of color to foster preventive and public health programs that incorporate each community's own strengths and values.

LISA DOI is the President of the Japanese American Citizens League, Chicago Chapter. She is an alumna of JACL Chicago's Kansha Project and is active in shaping the organization's engagement of young Japanese Americans. In addition, Lisa is an active member of the Midwest Buddhist Temple and is a Trustee of North Shore Country Day School. Professionally, Lisa is the Research & Evaluation Manager at IFF, doing program evaluation and research on projects and cities across the Midwest. Lisa received a BA in Anthropology & Urban Studies from the University of Pennsylvania and an MA in Social Science from the University of Chicago, where her research focused on the resettlement and dispersal patterns of Japanese Americans to Chicago after their World War II incarceration.

ANNA TAKADA is the former Oral History Project Coordinator at the Japanese American Service Committee in Chicago, where she worked in partnership with the Chicago Japanese American Historical Society to record firsthand experiences of World War II incarceration and resettlement of Japanese Americans. Prior to her current position, Anna served on the exhibitions and curatorial teams at Alphawood Gallery, where she helped coordinate the 2017 exhibition *Then They Came for Me: Incarceration of Japanese Americans During World War II and the Demise of Civil Liberties*. Her passion for community development, historic preservation, and public education has also been reflected in her volunteer work, as she assists various programs designed to educate on Japanese American World War II incarceration, including the Kansha Project of the Japanese American Citizens League and annual Day of Remembrance programs. From 2016 to 2017, Anna worked closely with The Block Museum through her position as Graduate Assistant at Northwestern's Multicultural Student Affairs. She was honored to serve as a liaison to assist in increasing engagement with Northwestern students and the local Japanese American community.

LAUREN COCHARD WATKINS is the former Engagement Manager at The Block Museum of Art where she oversaw student initiatives, community partnerships, and the tours and student docent program. Prior to her work at The Block, she managed programs for families, youth, teachers, and students at the Museum of Contemporary Art, Chicago; the Chicago Architecture Foundation; and the National Building Museum in Washington, DC. Lauren holds a BA in Art History from Carleton College and an MA in Art and Design Education from the Rhode Island School of Design. Throughout her career she has been fueled by a passion for making museums be places of vitality—as living, open, and generous public institutions.

EXHIBITION CHECKLIST

KRISTINE AONO
Born Chicago, 1960; lives Silver Spring,
Maryland

The Nail That Sticks Up the Farthest..., 2017
Mixed-media installation
134 1/2 x 566 1/2 inches
Courtesy of the artist

SHAN GOSHORN
Born Baltimore, 1957; died Tulsa, Oklahoma,
2018

Cherokee Burden Basket: A Song for Balance,
2012
Arches watercolor paper splints printed with
archival inks, acrylic paint
18 3/4 x 18 3/4 x 23 1/4 inches
Collection of the artist
(Now in the collection of Mary & Leigh Block
Museum of Art, Northwestern University,
purchase with a gift from Sandra Lynn Riggs
and members of the Block Leadership Circle,
2017.3)

Distorted View, 2015
Arches watercolor paper splints printed with
archival inks, acrylic paint
6 1/2 x 6 1/2 x 19 1/2 inches
Private collection

Prayers for Our Children, 2015
Arches watercolor paper splints printed with
archival inks, acrylic paint
11 1/4 x 11 1/4 x 20 1/2 inches
Private collection

*Sealed Fate: Treaty of New Echota Protest
Basket*, 2010
Arches watercolor paper splints printed with
archival inks, acrylic paint
12 x 22 x 12 inches
Collection of the Gilcrease Museum, Tulsa,
Oklahoma
Gilcrease Museum Management Trust

Smoke Screen, 2015
Arches watercolor paper splints printed with
archival inks, acrylic paint
4 3/4 x 4 3/4 x 5 1/2 inches
Private collection

SAMANTHA HILL
Born Philadelphia, 1974; lives Philadelphia

*Herbarium: A historic reflection inspired by
the Mason family collection*, 2015–2017
Tintype installation
Dimensions variable
Courtesy of the artist

MCCALLUM & TARRY
Active 1998–2013
Bradley McCallum, born Green Bay,
Wisconsin, 1966; lives Brooklyn
Jacqueline Tarry, born Buffalo, New York,
1963; lives Brooklyn

Exchange, 2007
HD video with sound; 3:46 minutes
Courtesy of the artists
Direction, cinematography, and editing:
Gavin Rosenberg
Audio: Brian Harnetty

DARIO ROBLETO
Born San Antonio, 1972; lives Houston

No One Has A Monopoly Over Sorrow, 2004
Men's wedding-ring finger bones coated in
melted bullet lead from various American
wars, men's wedding bands excavated from
American battlefields, melted shrapnel,
wax-dipped preserved bridal boutiques of
roses and white calla lilies from various eras,
dried chrysanthemums, male-hair flowers
braided by a Civil War widow, fragments of
a mourning dress, cold-cast brass, bronze,
zinc, and silver, rust, mahogany, glass
11 x 10 x 9 inches
Private collection

Defiant Gardens, 2009–10
Cut paper, homemade paper (pulp made from soldiers' letters home and wife/sweetheart letters to soldiers from various wars, cotton), thread and fabric from soldiers' uniforms from various wars, carrier pigeon skeletons, World War II–era pigeon message capsules, dried flowers from various battlefields, hair flowers braided by war widows, mourning dress fabric, excavated shrapnel and bullet lead from various battlefields, various seeds, various seashells, cartes de visite, gold leaf, silk, ribbon, wood, glass, foam core, glue
79 1/2 x 61 x 4 1/2 inches
Collection of the Mint Museum, Charlotte, North Carolina, Gift of the Mint Museum Auxiliary. 2012.6

MARIE WATT
Born Seattle, 1967; lives Portland, Oregon

Companion Species: Ferocious Mother and Canis Familiaris, 2017
Reclaimed wool blankets and embroidery floss
108 x 219 inches
Courtesy of the artist, commissioned by The Block Museum of Art
(Now in the collection of Portland Art Museum, Portland, Oregon)

Transportation Object (Letter Ghost), 2014
Reclaimed wool blankets, satin binding, embroidery floss
9 x 10 inches
Collection of Susan and Bruce Winthrop

Transportation Object (Potlatch), 2014
Reclaimed wool blankets, satin binding, embroidery floss
15 x 16 inches
Courtesy of PDX Contemporary Art, Portland, Oregon, and Greg Kucera Gallery, Seattle

Witness, 2015
Reclaimed wool blanket, embroidery floss, thread
71 x 180 1/2 inches
Courtesy of PDX Contemporary Art, Portland, Oregon, and Greg Kucera Gallery, Seattle
(Now in the collection of Jordan Schnitzer Museum or Art, University of Oregon, Eugene, Oregon)

ENGAGEMENT ACTIVITIES AND PROGRAMS

The following is a comprehensive chronological list of the activities in relationship to the exhibition *If You Remember, I'll Remember* and entwined artist projects. This includes public programs hosted at the Block and devised in partnership with numerous collaborators; smaller-scale events or activities including some organized independently by other groups; as well as more intimate, behind-the-scenes experiences and exchanges between artists and individuals on and off campus.

FALL SITE VISIT
With Kristine Aono
October 18–19, 2016

MEETINGS WITH NORTHWESTERN FACULTY AND STAFF AND LEADERS OF COMMUNITY-BASED ORGANIZATIONS

Alan Anderson, Executive Director of Neighborhood and Community Relations, Northwestern University
Jabbar Bennett, Associate Provost for Diversity and Inclusion, Northwestern University
Keisha Barnard, Learning and Development Coordinator, Youth & Opportunity United (Y.O.U.)
Theresa Bratanch, Manager of Diversity and Inclusion, Northwestern University
Robert Brown, Director, Social Justice Education, Northwestern University
Jean Mishima, Chicago Japanese American Historical Society
Michael Takada, Japanese American Service Committee
Casey Varela, Manager of Strategic Partnerships, Youth & Opportunity United (Y.O.U.)
Ryan Yokota, Japanese American Service Committee
Mari Yamagiwa, Japanese American Citizens League

INTERVIEW

With Lindsay Bosch, Communications Manager, The Block Museum of Art

DINNER WITH NORTHWESTERN STUDENT ORGANIZATION LEADERSHIP

Asian Pacific American Coalition members: Stacy Jacki Tsai, Leslie Zhang, Florence Fu
Immigrant Justice Project members: Ana Acevedo, Hayeon Kim
Sustained Dialogue Leadership Team: Daniela Guerrero, Jessica Lewis

CLASS VISIT

To Freshman Seminar taught by Laura Hein, Harold H. and Virginia Anderson Professor of History

COFFEE / INFORMATION SESSION ATTENDEES

Alexander Harusuke Furuya, Northwestern University Medill School of Journalism Class of 2018
Jill Mannor, Communications Coordinator, Alice Kaplan Institute for the Humanities, Northwestern University
Christine Munteanu, Assistant Director of Multicultural Student Affairs, Northwestern University
Riona Oshima-Ryan, Northwestern University Bienen School of Music Class of 2019
Rosie Roche, Arts Manager, Northwestern University
Yumi Shiojima, Associate Professor of Japanese, Asian Languages and Cultures, Northwestern University
Danny Snelson, 2015-2017 Andrew W. Mellon Postdoctoral Fellow in Digital Humanities at the Alice Kaplan Institute for the Humanities, Northwestern University
Anna Takada, Multicultural Student Affairs, Northwestern University
Wendy Wall, Director of the Alice Kaplan Institute for the Humanities, Northwestern University
LaCharles Ward, PhD candidate, Rhetoric and Public Culture, Northwestern University
Kelly Wisecup, Associate Professor of English; Director of Undergraduate Studies, Department of English, Northwestern University

FALL SITE VISIT
With Marie Watt
November 8–9, 2016

MEETINGS WITH NORTHWESTERN FACULTY AND STAFF AND WITH LEADERS OF COMMUNITY-BASED ORGANIZATIONS

Keisha Barnard, Learning and Development Coordinator, Youth & Opportunity United (Y.O.U.)
Ninah Divine, Coordinator, Native American and Indigenous Peoples Steering Group
Bonnie Etherington, Treasurer, Colloquium on Indigeneity and Native American Studies (CINAS), PhD English Language and Literature, Northwestern University
Loren Ghiglione, Professor Emeritus, Northwestern University (then chair of Native American and Indigenous Peoples Steering Group)
Lorenzo Gudino, President of the Native American and Indigenous Student Alliance, Northwestern University Class of 2017
Jasmine Gurneau, Multicultural Student Affairs & Undergraduate Student Admissions
Nell Haynes, Visiting Assistant Professor, Department of Anthropology, Northwestern University
Dave Spencer, American Indian Center
Casey Varela, Manager of Strategic Partnerships, Youth & Opportunity United (Y.O.U.)
Kelly Wisecup, Associate Professor of English; Director of Undergraduate Studies in the Department of English

INTERVIEW

With Janet Dees, Curator, and Lindsay Bosch, Communications Manager, The Block Museum of Art

CLASS VISIT

To "Topics in Native American and Indigenous Literatures: Louise Erdrich, Winona LaDuke, & Great Lakes Native American Writers," class taught by Kelly Wisecup, Associate Professor of English, Northwestern University

Alan Anderson, Executive Director of Neighborhood and Community Relations, Northwestern University

Libia Bianibi, Masters student, Arts Administration & Policy, School of the Art Institute of Chicago

Theresa Bratanch, Manager Diversity and Inclusion, Northwestern University

Misty DeBerry, PhD candidate, Department of Performance Studies, Northwestern University

Robert Brown, Director, Social Justice Education, Northwestern University

Sarah Dees, Luce Postdoctoral Fellow and Visiting Assistant Professor, Department of Religious Studies, Northwestern University

Celina Flowers, Director of Faculty, Office of the Provost, Northwestern University

Heidi Gross, Assistant Director, Center for Civic Engagement, Northwestern University

Doug Kiel, Assistant Professor, Department of History, Northwestern University

Elizabeth Lewis Pardoe, Director of the Office of Fellowships, Northwestern University

Jill Mannor, Communications Coordinator, Alice Kaplan Institute for the Humanities, Northwestern University

Liz McCabe, Lecturer, Chicago Field Studies, Northwestern University

Patricia Nguyen, PhD candidate, Department of Performance Studies, Colloquium for Ethnicity and Diaspora, Northwestern University

Tyler Pager, Northwestern University Medill School of Journalism Class of 2017

Debra Yepa-Pappan, Community Engagement Coordinator, Chicago Field Museum

DOCENT TRAINING
With Curator Janet Dees
January 12, 2017

Curator Janet Dees led a dialogue-driven training for Block Museum student docents.

DOCENT TRAINING
With Social Justice Education
February 2, 2017

Robert Brown and Noor Ali, Director and Associate Director of the Office of Social Justice Education at Northwestern, led a professional development session for Block student docents around strategies for facilitating open-ended dialogue, particularly around issues of identity, lived experience, justice, and injustice.

PUBLIC PROGRAM
Opening Day: *If You Remember, I'll Remember*
Saturday, February 4, 2017

SEWING KICK-OFF

The exhibition *If You Remember, I'll Remember* was an invitation to think about the present while reflecting on the past. Visitors dropped in for a first look at the exhibition and joined artist Marie Watt in a sewing circle.

The contemporary artists in the exhibition used poetic strategies to address issues of war, racism, and xenophobia in American history. Exhibition curator Janet Dees and participating artists Kristine Aono, Samantha Hill, Dario Robleto, and Marie Watt took part in a presentation and panel discussion on the show's crucial themes.

MEETING
With Marie Watt and Native American and Indigenous Student Alliance (NAISA)
February 7, 2017

Marie Watt met informally with undergraduate student representatives from NAISA. Students contributed words they associated with equity that were then used in the Equity Sewing Circle the following evening.

PUBLIC PROGRAM
Equity Sewing Circle with Artist Marie Watt
Wednesday, February 8, 2017

Blankets, one of the primary materials used by Seneca artist Marie Watt, are everyday objects that can carry extraordinary histories. Many of Watt's larger blanket works are made in community, notably in "sewing circles," to bring people together in conversation and making. Over 140 community members joined us for hands-on participation in one of Watt's projects, while also taking part in conversation on the theme of equity.

Partners included Northwestern's Native American and Indigenous Peoples Steering Group, Native American & Indigenous Studies Association, Northwestern's Colloquium on Indigeneity and Native American Studies, Multicultural Student Affairs, and the office of Neighborhood and Community Relations.

DOCENT TRAINING
February 9, 2017

Block student docents participated in a workshop to devise approaches to touring the exhibition.

FILM
History and Memory
February 9, 2017

In conjunction with the exhibition *If You Remember, I'll Remember*, curator Janet Dees introduced two films by artist Rea Tajiri that highlight personal experiences of the internment of Japanese Americans during World War II—*History and Memory* (1991) and *Yuri Kochiyama: Passion for Justice* (1994)

DISCUSSION
Northwestern Colloquium for Ethnicity and Diaspora (CED) Reading Group
February 16, 2017

Members of CED participated in a guided tour followed by a discussion of the novel *Homegoing* (2016) by Yaa Gyasi.

PUBLIC PROGRAM
Deru Kugi Wa Utareru: Stories of Internment and Remembrance
February 18, 2017

February 19, 2017 marked the 75th anniversary of the signing of the executive order which called for the incarceration of Japanese Americans during World War II. The Block commemorated this historic occasion through an interactive, intergenerational program held in the galleries around the work of artist Kristine Aono. The afternoon was spent hearing individuals who had been incarcerated share their stories. The film *History and Memory* by Rea Tajiri was also screened.

Hosting partners included Multicultural Student Affairs and the Japanese American Service Committee, Chicago Japanese American Historical Society, Japanese American Citizens League, Japanese Mutual Aid Society, and the Chicago Japanese American Council.

PUBLIC PROGRAM
Cultural Production, State Violence, and Subjected Positions of Transgressions
March 1, 2017

The Northwestern Colloquium for Ethnicity and Diaspora provides a space for interrogating current issues of citizenship, race, and ethnicity. Visitors joined for a panel that examines how national and state power leads to criminalization of racialized, gendered, queer(ed), and classed bodies. Speakers focused on the impact of visual culture in shaping continual and momentary "states of emergency" and the way that this violence is documented, archived, and remembered.

DIALOGUE
Sustained Dialogue Pop-Up
March 8, 2017

Student leaders from Northwestern's Sustained Dialogue invited their fellow students to engage in conversation in the gallery around immigrant and American identities.

PROFESSIONAL DEVELOPMENT
With Multicultural Student Affairs
March 21, 2017

Jasmine Gurneau, Christine Munteanu, and Anna Takada of Multicultural Student Affairs (MSA) co-organized with Janet Dees and Lauren Watkins of The Block a professional development session for their colleagues in MSA. Following a guided tour by Janet Dees, the group participated in a dialogue around the implications of the ideas and experiences that the exhibition surfaced for their work with students at Northwestern.

FAMILY NIGHT
With Youth & Opportunity United (Y.O.U.)
March 22, 2017

The Block hosted a family-oriented event for Y.O.U. students from Dawes and Walker elementary schools in Evanston performed original stories. Following the program, families were invited to explore the exhibition *If You Remember* using a family guide designed especially for the occasion to uncover the stories behind the works of art.

WORKSHOP
Sewing Circle with Marie Watt at Dr. Martin Luther King Jr. Literary and Fine Arts School
April 19, 2017

Marie Watt facilitated a sewing circle taking up the theme of equity with middle school students who participate in Y.O.U.'s after-school programming at King Arts in Evanston. The resulting piece still hangs at Y.O.U. headquarters.

SEWING CIRCLE DEBRIEF
With Marie Watt and Sewing Circle partners
April 20, 2017

We reconvened with key partners for the February 8 Equity Sewing Circle to debrief the event and celebrate the work that came out of it, including Marie Watt's new piece.

CLASS VISIT
With Marie Watt
April 20, 2017

Marie Watt did an artist talk for Professor Rebecca Zorach's class "Art, Ecology, and Politics."

PUBLIC PROGRAM
Marie Watt: Sewing Community
April 20, 2017

In Winter 2017, community members from Northwestern, Evanston, and beyond had joined together with artist Marie Watt to lend their hands to sewing circles, embroidering words of equity, maternity, and empowerment. These stitches and conversations became part of a new work for the exhibition *If You Remember, I'll Remember*. Community members who contributed to the project joined us for the unveiling of this project and spoke with Watt about her community-based and participatory practice.

CONFERENCE
Open Engagement Open House
April 21, 2017

The Block Museum welcomed artists, scholars, practitioners, and advocates of socially engaged art from around the world visiting for the free Open Engagement national conference. Curator Janet Dees introduced *If You Remember, I'll Remember*, artist Samantha Hill shared her work on the American South, public practice curator Susy Bielak described the partnerships involved in community-based practice, and Professor Rebecca Zorach went behind the scenes with her and her students' exhibition *We Are Revolutionaries: The Wall of Respect and Chicago's Mural Movement*, which was on view at the Block Museum of Art, April 21–June 18, 2017.

The program was presented in conjunction with the conference Open Engagement 2017 – JUSTICE.

PUBLIC PROGRAM
Reparations in the Native American and Japanese American Context
April 26, 2017

What does it mean to be indebted—politically, economically, artistically, or ethically? Artist Kristine Aono, whose work was featured in the exhibition *If You Remember, I'll Remember*, was joined by Smith University's Laura Fugikawa (Women and Gender Studies) as well as Northwestern's Kelly Wisecup (English) to discuss the theory and complexity of reparations in American history.

Co-presented by the Kaplan Institute for the Humanities and made possible in part by the support of the Harris Lecture Fund.

WORKSHOP
With Kristine Aono and Youth & Opportunity United (Y.O.U.)
April 27, 2017

Kristine Aono gave an artist talk and led interactive activities, using her artwork as a springboard, for elementary and middle schoolers participating in Y.O.U. after-school programs.

PARTNER DINNER
Kristine Aono with partners from the Deru Kugi Wa Utareru program
April 27, 2017

We reconvened with key partners from the Deru Kugi Wa Utareru: Stories of Internment and Remembrance program in February and Kristine Aono to share personal stories and reflections from the event.

ARTIST TALK
Kristine Aono with members of the Asian American Heritage Alliance
April 28, 2017

Kristine Aono gave a talk and led a dialogue at Evanston Township High School with members of the Asian American Heritage Alliance.

WORKSHOP
Kristine Aono with members of Japanese American Student Association (JASA)
April 28, 2017

Kristine Aono led a writing workshop, exploring stories about objects that carry memory for student members of JASA.

WORKSHOP
Poetry of Witness
May 3, 2017

Participants read and discussed poems that repurposed found text to weave documentary works of witness through collage, juxtaposition, and response. After engaging with the exhibition, participants composed original poems that reframed individual experience through historical texts and materials.

This workshop was led by Maggie Queeney of the Poetry Foundation. It was held in conjunction with the Evanston Literary Festival.

PUBLIC PROGRAM
The Pulse Armed with a Pen: An Unknown History of the Human Heartbeat
May 10, 2017

Transdisciplinary artist and "citizen-scientist" Dario Robleto was featured in the exhibition *If You Remember, I'll Remember* and currently serves as Artist in Residence in Neuroaesthetics at the University of Houston's Cullen College of Engineering. In a performative lecture that was part storytelling, part original research, and part rare-sound archive, Robleto expanded on his research into the human heartbeat.

Presented in partnership with the McCormick School of Engineering

FILM
The Loving Story
May 11, 2017

Janet Dees, curator of *If You Remember, I'll Remember*, selected Nancy Buirski's documentary film *The Loving Story* (2011) to screen in conjunction with the exhibition. The exhibition features McCallum & Tarry's *Exchange* (2007), which resonates with this film's subjects, Richard and Mildred Loving. Through interviews and historical documentation, the documentary illuminates the story of the Lovings, who were taken into custody and imprisoned in 1958 for illegally co-habitating as a mixed-race couple because their marriage represented a violation of Virginia's Racial Integrity Act. The documentary served as inspiration for the Hollywood adaptation *Loving* (2016).

IMAGE CREDITS

PAGES 6–7: Photo by Clare Britt
PAGE 10: Courtesy of the artist;
Photo by Clare Britt
PAGE 16: Photo by Clare Britt
PAGES 22, 26, 27: Courtesy of the artist
PAGES 28, 29: Courtesy of the artist;
Photos by Clare Britt
PAGE 30: Courtesy of McCallum & Tarry;
Photo by Clare Britt
PAGES 32–33: Courtesy of the artist;
Photo by Aaron Johanson
PAGE 34: Courtesy of the Royal BC
Museum and Archives (Image PN1500);
Photo by Reverend Tate
PAGES 36–37, 38,39: Courtesy of the
artist; Photos by Clare Britt
PAGES 40, 41: Courtesy of the estate of
the artist
PAGE 42: Courtesy of the estate of the artist
PAGE 43: Photo by Clare Britt
PAGES 44–45: Courtesy of the artist;
Photo by Clare Britt
PAGE 46: Courtesy of the artist;
Photo by Aaron Johanson
PAGES 52–53: Photo by Clare Britt
PAGE 54: Courtesy of the artist;
Photo by Clare Britt
PAGE 64: Photo by Sean Su
PAGES 64, 66: Photos by Sean Su
PAGE 67: Courtesy of the artist and
The Aldrich Contemporary Art Museum
PAGE 68: Photo by Sean Su
PAGES 70, 71, 72, 73, 74, 75, 76, 78, 79:
Photos by Sean Su
PAGE 84: Courtesy of the artist;
Photo by Clare Britt
PAGES 86, 90, 92, 96, 100, 104: Photos by
Sean Su
PAGE 106: Photo by Lauren Watkins
PAGE 113: Photos by Sean Su
PAGES 114–115: Photo by Clare Britt

Published in conjunction with the
exhibition *If You Remember,
I'll Remember*, at The Block Museum of Art,
Northwestern University,
February 4–June 18, 2017

This publication has been made
possible in part by support from the
Sandra L. Riggs Publications Fund.

Design, Copy Editing by AHL&CO

Printed by Shapco Printing, Minneapolis

www.blockmuseum.northwestern.edu

Front cover: Samantha Hill,
*Herbarium: A historic reflection inspired
by the Mason family collection* (detail),
2015–17, Installation view at
The Block Museum of Art, 2017. Courtesy
of the artist; photo by Clare Britt.

ISBN 978-1-7325684-3-3